January 2008 London

Dear & George

Lovely to see you both
again. Best wishes for
the year ahead and I
hope to see much more
of you in the future.

Pierre

ENTER EXIT

PIERRE CROCQUET DE ROSEMOND

With a foreword by Rick Wester and an essay by Eugen Blume

HATJE
CANTZ

FOREWORD

[R i c k W e s t e r]

In Pierre Crocquet de Rosemond's photographs of the disaffected population in a small South African town, the people are seen as honestly and objectively as in a court stenographer's report, with no obvious style or consciously applied veneers of persuasion. They are who they are, and that is that. Yet, without manipulation or overtly fashionable direction, Crocquet finds much to celebrate by simply allowing these men, women, and children—his neighbors, his community, his country—to be in their own skin, an undiminished accomplishment for that part of the world; and for a photographer, a deceptively difficult feat. However, these people are also aristocrats, a point not lost on Crocquet. Another photographer, Diane Arbus, found royalty in her subjects as well, but where Arbus worked hard to wedge her way into her subjects' lives, Pierre Crocquet's entrée is diplomatic privilege; all visas and passports come already validated. We are well into the first decade of the twenty-first century, and Crocquet has seemingly uncovered the members of a surviving tribe, born to the land and to each other, but unknown to those of us unattached to the earth. With the perimeter of their small village and a limited range of characters, the photographs in this book, surprisingly, attain a broader context, where the people define the state, not vice versa. Equality, democracy, and respect all reside within the borders of these pictures, sharing the fields with alienation, disappointment, and perseverance. The fact that these photographs are in black and white is appropriate, for the obvious implications, and for the intangible parity monochrome representation achieves by simplification. The colors and textures of the world reduce themselves to a gray scale stretching from brightest morning to deepest night.

But photography is a complex endeavor. No photographic narrative is ever less than the sum of its parts. While a picture is always about something out there, it is also always about the photographer's eye. No photograph describes the world without simultaneously describing the photographer. What details the camera unites in a photograph will narrate the frame of the picture space. Through the sheer act of editing the world, they are always a reflection of the hand, brain, and heart of the maker. Photographs tend to invite the viewer to "read into the picture," but really, description should be enough. No embellishment is needed if the drama of the world, reduced to two dimensions and an array of grays and blacks and whites, is convincingly conveyed. The cover of this book, image 5, is littered with visual signifiers generating a psychological complexity only photography can attain. A young black African, a boy, accompanies a doubly amputated old Afrikaner on the side of a dusty road. They are measured not only by the camera and its submarine angle, hugging the ground, but also by the contrasts between the sitters: youth and age; black skin and white—the first smooth and lovely, the latter chiseled and wizened. A pair of lampposts in the background frames an empty space emphasizing the boy's height against the man's lost stature. The crossbars of the wheelchair's frame are startlingly revealed by the loss of the old man's legs. Description is narrative; description is enough.

Crocquet's portraits are situational documents, environmental tableaus; his subjects convey an intimate allegiance to their surroundings. What one notices immediately is that the people he photographs are mostly accompanied by the accoutrements of their lives—their tools, their furniture, their clothes, and their fellow South Afrikaners. They are nearly inseparable; they can't be extricated from their surroundings, or from each other. A weathered woman knits in the sunlight while seated at what appears at first to be an impossibly tangled mesh-top table and matching chairs, the geometry of which suggests an intricate trompe l'oeil of her own genesis, from her own hand. Upon closer inspection, however, it is simply the organization of the seating arrangement that makes the scene so puzzling. Visually, she is woven into the furniture in an uncertain space while reigning over the entire scene, a celestial queen weaving endlessly, drawn in a constellation of steel frames, hemp lattice, and wool yarn.

Ever since Walker Evans faced the American vernacular landscape and its people, photographers have used the medium to elevate the banal into the sublime by allowing the medium's power of description and its inalienable status as a cousin of reality to impart and, therefore, instruct us to see the central importance of how what we surround ourselves with drives life. Evans, accompanied by the writer James Agee, traveled during the summer of 1936, taking notes and creating dozens of pictures describing the life, times, homes, vocations, and community of white sharecropper families during the Great Depression in Alabama, resulting in *Let Us Now Praise Famous Men*. Of all the pictures included, one stands apart as a paean of exalted description, a picture so simple and direct yet so transcendental that it describes heaven as easily as it details hell. *Kitchen Wall in Bud Field's Home, Hale County, Alabama, Summer 1936* is essentially a still life, a stripped-down, minimalist, and modern equivalent of the seventeenth-century Dutch genre. On a wall barely insulated from the outdoors, a handful of eating utensils, not nearly enough for each family member to have its own set, hang vertically in a makeshift holder nailed to the wall. Magically, they appear to float in space, unattached and free, held aloft invisibly, as if by angels. This effect, caused by a repeating motif of darker shapes below the holder that echo it as if they were shadows cast by lights above, elevating this scene to a higher plane, stripping it of its pedantic banality, creates a spiritually unique experience—the photographic equivalent of turning water into wine. Evans saw Bud Field's kitchen wall metonymically, as a stand-in double for all that wrapped itself around the lives of the poor, the dispossessed, and the beholden. As such, it is in purpose and effect the precedent to Pierre Crocquet's essay.

Books are surveyed word by word, page by page, picture by picture. *Enter Exit*, like any good novel or play, has a cumulative effect, developing themes and directions as it progresses. Each mise-en-scène of Crocquet's choosing plays off its predecessors and informs its successors, expanding the parameters of the book's characters and enriching our world as well. Each being, within each scene, builds on itself and, as after any good story, leaves the viewer sensing that the world is bigger, a little stranger, and understood more, but known less, than before.

Rick Wester

VORWORT

[R i c k W e s t e r]

In seinen Fotografien der desillusionierten Bevölkerung einer kleinen südafrikanischen Gemeinde zeigt Pierre Crocquet de Rosemond die Menschen so unverstellt und objektiv wie ein Gerichtsstenograf, ohne erkennbare stilistische Merkmale oder bewusste Beeinflussung. Sie sind, wer sie sind, und das war's. Und dennoch lässt Crocquet diese Männer, Frauen und Kinder – seine Nachbarn, seine Landsleute – hochleben, indem er sie einfach sie selbst sein lässt; für diesen Teil der Welt schon eine Leistung an sich und für einen Fotografen eine Meisterleistung, die sich erst auf den zweiten Blick erschließt. Diese Menschen sind jedoch auch Aristokraten, und Crocquet ist sich dessen bewusst. Eine andere Fotografin, Diane Arbus, sah auch Königliches in ihren Modellen, doch während sie sich ihren Weg in das Leben ihrer Modelle hart erarbeiten musste, genießt Pierre Crocquet in der Welt der Seinen diplomatische Immunität; alle Pässe und Visa sind bereits ausgestellt. Zu Beginn des 21. Jahrhunderts nun hat Crocquet offenbar einen Stamm entdeckt, dem es gelungen ist, zu überleben, der dem Boden seiner Ahnen treu geblieben ist und der sich selbst genügt. Denen unter uns, die ohne Bodenhaftung sind, ist er unbekannt. Auf dieses kleine Dorf und seine Bewohner beschränken sich die Fotografien in diesem Buch, doch erstaunlicherweise gehen sie weit über diesen engen Kontext hinaus und zeigen eine Welt, die von den darin lebenden Menschen bestimmt wird, nicht umgekehrt. Gleichheit, Demokratie und Respekt sind in diesen Bildern ebenso zu Hause wie Entfremdung, Enttäuschung und Beharrlichkeit. Die Schwarz-Weiß-Fotografie ist das richtige Ausdrucksmedium für diese Bilder, der offensichtlichen Implikationen wegen und weil die monochrome Darstellung durch Vereinfachung eine unbestimmbare Gleichheit erreicht. Die Farben und Texturen der Welt reduzieren sich auf eine Grauskala, die sich vom hellsten Morgen bis zur tiefsten Nacht erstreckt.

Die Fotografie ist ein komplexes Unterfangen. Nie ist eine fotografische Erzählung weniger als die Summe ihrer Teile. In einem Bild geht es immer um »Etwas« draußen in der Welt, immer aber auch um das Auge des Fotografen. Keine Fotografie beschreibt die Welt, ohne zugleich den Fotografen zu beschreiben. Die Details, die die Kamera in einer Fotografie vereint, bestimmen das, was im Bildraum erzählt wird. Durch den bloßen Akt der Aufbereitung der Welt ist eine Fotografie immer auch eine Reflexion der Hand, des Hirns und des Herzens des Fotografen. Fotografien laden den Betrachter für gewöhnlich dazu ein, etwas »in das Bild hineinzulesen«, doch tatsächlich reicht Beschreibung völlig aus. Es bedarf keiner Ausschmückung, wenn das auf zwei Dimensionen und eine Reihe von Grau-, Schwarz- und Weißtönen reduzierte Drama der Welt überzeugend übermittelt wird. Das Umschlagbild dieses Buches, Bild 5, ist mit visuellen Signifikanten übersät, die eine psychologische Komplexität generieren, die nur die Fotografie erreichen kann. Ein schwarzer Afrikaner, ein Junge, begleitet einen doppelt amputierten alten Buren auf einer staubigen Straße. Sie werden nicht nur von der Kamera mit ihrem den Boden berührenden submarinen Aufnahmewinkel abgemessen, sondern auch durch die Kontraste zwischen den beiden Modellen: Jugend und Alter, schwarze und weiße Haut – die schwarze glatt und schön, die weiße zerfurcht und runzlig. Zwei Laternenpfähle im Hintergrund umrahmen einen leeren Raum, der die Größe des Jungen gegen die dem alten Mann gebliebene Statur hervorhebt. Die fehlenden Beine geben einen erschreckenden Blick auf die Querstangen des Rollstuhlgestells frei. Beschreibung ist narrativ; Beschreibung reicht aus.

Crocquets Porträts sind Dokumente einer Situation, Bilder einer Umwelt, sie vermitteln eine innige Bindung seiner Modelle an ihre Umgebung. Was man auf den ersten Blick bemerkt: Fast alle Menschen, die er fotografiert, zeigen sich zusammen mit dem, was zu ihrem Leben dazugehört – ihren Gerätschaften, ihrer Einrichtung, ihrer Kleidung, ihren Mitmenschen. Sie sind beinahe unzertrennbar; sie können weder voneinander noch von ihrer Umgebung losgelöst werden. Eine verwitterte Frau sitzt auf einem Drahtstuhl an einem Drahttisch und strickt im Sonnenlicht. Auf den ersten Blick ein unmöglich verheddertes Ensemble, dessen Geometrie an ein kompliziertes, aus ihrer eigenen Hand hervorgegangenes Trompe-l'Œil denken lässt. Was die Szene so verwirrend macht, ist bei näherer Betrachtung jedoch einfach nur die Anordnung der Sitzgruppe. Die visuell in einem unbestimmten Raum mit der Einrichtung verwobene Frau beherrscht die ganze Szene, eine endlos webende, in eine Konstellation aus Stahlrahmen, Hanfgeflecht und Wollgarn hineingezogene himmlische Königin.

Seit Walker Evans die amerikanische Landschaft und ihre Menschen porträtierte, haben Fotografen ihr Medium eingesetzt, um das Banale erhaben werden zu lassen. Sie erheben es, indem sie die Beschreibungskraft der Fotografie und ihren unveräußerlichen Status als Schwester der Realität hervortreten und uns damit erkennen lassen, wie die Dinge und die Menschen, mit denen wir uns umgeben, unser Leben bestimmen. Im Sommer 1936 reiste Evans zusammen mit dem Schriftsteller James Agee durch Alabama und beschrieb in Notizen und Dutzenden von Bildern die Lebensbedingungen, Behausungen, Beschäftigungen und Gemeinschaften weißer Farmpächterfamilien in der Zeit der Großen Depression. Das Ergebnis war das Buch *Let Us Now Praise Famous Men*. Unter allen darin versammelten Bildern sticht eines als eine Hymne auf die erhebende Beschreibung hervor, ein Bild, das so einfach und unmittelbar und dabei so transzendental ist, dass es den Himmel so leicht beschreibt, wie es die Hölle in allen Einzelheiten zeigt. *Kitchen Wall in Bud Field's Home, Hale County, Alabama, Summer 1936* ist im Grunde genommen ein Stillleben, ein reduziertes, minimalistisches und modernes Äquivalent des niederländischen Stilllebens des 17. Jahrhunderts. An einer nur notdürftig gegen Wind und Wetter isolierten Wand hängt eine Handvoll Essutensilien, bei Weitem nicht genug, als dass jedes Mitglied der Familie sein eigenes Besteck hätte, vertikal in einem behelfsmäßig angenagelten Halter. Sie scheinen auf magische Weise im Raum zu schweben, losgelöst und frei, von unsichtbarer Hand emporgehoben, als wären Engel im Spiel. Diese Wirkung – hervorgerufen durch ein sich wiederholendes Motiv dunklerer Formen unterhalb des Halters, die dessen Form aufgreifen, als wären sie von oben hereinstrahlendem Licht geworfene Schatten – hebt diese Szene auf eine höhere Ebene, nimmt ihr ihre pedantische Banalität, bringt eine spirituell einzigartige Erfahrung hervor: die fotografische Entsprechung der Umwandlung von Wasser zu Wein. Evans sah Bud Fields Küchenwand metonymisch, stellvertretend für alles das, was sich um das Leben der Armen, der Besitzlosen und der Verschuldeten legt. Hinsichtlich seiner Zielsetzung und seiner Wirkung nimmt dieses Bild Pierre Crocquets Fotoessay vorweg.

Ein Buch wird Wort für Wort, Seite für Seite, Bild für Bild in Augenschein genommen. *Enter Exit* hat, wie jeder gute Roman, jedes gute Bühnenstück, eine kumulative Wirkung; im Verlauf des Buches entwickeln sich Themen und Richtungen. Jedes Bild, das Crocquet inszeniert, bezieht sich auf die vorangehenden und auf die folgenden Bilder, erweitert die Parameter der Charaktere des Buches und bereichert unsere Welt. Jeder Mensch in jeder Szene entwickelt sich aus sich selbst heraus und lässt, wie nach jeder guten Geschichte, den Betrachter mit dem Gefühl zurück, dass die Welt größer, ein wenig seltsamer und verständlicher – aber auch unbekannter – ist als zuvor.

Rick Wester

PRÉFACE

[R i c k W e s t e r]

Dans ses photographies de la population désillusionée d'un petit village sud-africain, Pierre Crocquet de Rosemond présente des hommes et des femmes avec la rigueur et l'objectivité d'un sténographe de tribunal : dénués de toute caractéristique stylisti-que et de tout vernis sciemment appliqué. Ils sont comme ils sont, un point c'est tout. Néanmoins, Crocquet célèbre ces hommes, ces femmes et ces enfants – ses voisins, ses compatriotes – en les laissant tout simplement être eux-mêmes ; une performance en soi dans cette partie du monde et pour un photographe un exploit discret. Pourtant, ces personnages sont aussi des aristocrates et Crocquet le sait. Une autre photographe, Diane Arbus, trouvait également quelque chose de royal à ses modèles. Cependant, là où Arbus travailla dur pour parvenir à s'introduire dans la vie de ses modèles, Pierre Crocquet, lui, dispose d'un passe diplomatique, les visas et passe-ports sont déjà tous validés. Au début du XXIe siècle, Crocquet semble avoir découvert les membres d'une tribu qui ont réussi à survivre, fidèles à la terre de leurs aïeux et se suffisant à eux-mêmes. Ils restent cependant inconnus à tous ceux qui ne possèdent pas de lien à la terre. Les photographies de ce livre se cantonnent certes à ce petit village et à ses habitants, mais elles dépassent les limites de ce cadre de façon surprenante et nous montrent un monde défini par les hommes y vivant et non inversement. L'égalité, la démocratie et le respect se partagent l'espace de ces photos autant que l'aliénation, la déception et l'opiniâtreté. La photographie en noir et blanc est la plus juste grâce à ses implications manifestes et parce qu'elle atteint un équilibre imperceptible grâce à la simplification créée par la représentation monochrome. Les couleurs et les textures de cet univers se réduisent à une échelle de gris qui s'étend des matins les plus clairs aux nuits les plus profondes.

La photographie est une entreprise délicate. La narration photographique n'est jamais moins que la somme de ses éléments. Dans un cliché il est toujours question d'un « quelque chose » extérieur, mais aussi de l'œil du photographe. Aucune photographie ne décrit le monde sans décrire aussi le photographe. Les détails rassemblés sur une photo grâce à l'objectif définissent ce qui est raconté dans l'espace du tableau. Le simple acte de traiter du monde fait de la photographie le reflet de la main, du cerveau et du cœur de son auteur. Habituellement, les photographies invitent l'observateur à « lire dans le tableau », mais dans les faits la description peut être amplement suffisante. Il n'y a pas besoin de fioritures lorsque le drame du monde est transmis de façon convaincante en deux dimensions et dans une série de tons gris, noirs et blancs. La couverture de cet ouvrage, photo 5, est surchargée de références visuelles générant une com-plexité psychologique que seule peut atteindre la photographie. Un jeune Africain noir accompagne un vieux Boer amputé des deux jambes sur une route poussièreuse. On prend leur mesure non seulement grâce à la position en contrebas de l'objectif, situé au niveau du sol, mais aussi grâce aux contrastes entre les deux modèles : la jeunesse et la vieillesse, la peau noire et la peau blanche – la noire lisse et belle, la blanche ridée et fripée. Deux réverbères à l'arrière-plan encadrent un espace vide qui accentue la grande taille du jeune homme par rapport à la stature perdue du vieil homme. L'absence des jambes offre une vue terrifiante sur les barres transversales du fauteuil roulant. La description est narrative, la description suffit.

Les portraits de Crocquet documentent une situation, représentent un milieu, transmettent un lien intime entre les modèles et leur environnement. On remarque immédiatement que presque toutes les personnes photographiées se laissent prendre en compagnie de ce qui fait partie de leur vie : leurs outils, leurs meubles, leurs habits et leurs compatriotes. Ils sont quasiment indissociables, ils ne peuvent être séparés ni les uns des autres ni de leur environnement. Une femme fânée tricote au soleil, assise à une table. Au premier regard, le mobilier donne l'impression d'un ensemble incroyablement enchevêtré dont la géométrie fait penser à un trompe-l'œil compliqué, produit par la main de cette femme. Mais ce qui rend la scène si déconcertante si l'on observe avec plus de précision, c'est tout simplement l'ordre de cet ensemble. La femme qui semble être elle-même tissée au milieu de cet ameublement dans cet espace indéfini domine toute la scène. Une reine céleste tissant sans fin au cœur d'une constellation de cadres en acier, de tiges de chanvre et de fils de laine.

Depuis que Walker Evans a dressé le portrait du paysage américain et de ses habitants, les photographes ont employé leur art à sublimer le banal. Ils l'élèvent en faisant ressortir la puissance descriptive de la photographie et son statut inaliénable de sœur de la réalité et nous laisse ainsi reconnaître à quel point les hommes et les choses dont nous nous entourons définissent nos vies. À l'été 1936, Evans parcourut l'Alabama en compagnie de l'écrivain James Agee et décrivit dans ses notes et ses douzaines de tableaux les conditions de vie, les habitations, les activités et les communautés de familles blanches de métayers à l'époque de la Grande Dépression. Il rassembla toutes ces données dans son ouvrage *Let Us Now Praise Famous Men*. Parmi tous les tableaux, l'un d'eux ressort comme hymne de la description au pouvoir de sublimation : un tableau si simple et direct qu'il en devient transcendental et qu'il décrit le ciel aussi simplement qu'il montre l'enfer dans tous ses détails. *Kitchen Wall in Bud Field's Home, Hale County, Alabama, Summer 1936* est essentiellement une nature morte, un équivalent réduit, minimaliste et moderne de la nature morte hollandaise du XVIIe siècle. Sur un mur, isolant provisoirement du vent et du mauvais temps, un cadre de fortune est cloué et supporte une poignée d'ustensiles de cuisine suspendue verticalement et insuffisante pour que chaque membre de la famille ait son propre couvert. Les ustensiles semblent flotter dans l'espace, comme par magie, libres et détachés, soutenus par une main invisible comme s'il s'agissait d'anges. Cet effet – provoqué par le motif répétitif de formes sombres sous le cadre qui semblent se faire écho comme si elles étaient les ombres produites par une lumière rayonnant au-dessus d'elles – élève cette scène à un niveau supérieur, il lui ôte sa banalité pédante et lui apporte une dimension spirituellement unique : le pendant photographique de la transformation de l'eau en vin. Evans a vu le mur de cuisine de Bud Fields comme une métonymie, la représentation de ce qui se rapporte à la vie des pauvres, des indigents et des endettés. Par l'objectif et l'effet qu'il recherche, ce tableau anticipe l'essai photographique de Pierre Crocquet.

On examine un livre mot à mot, page par page, image par image. *Enter Exit* a un effet d'accumulation, comme tout bon roman ou toute bonne pièce de théâtre ; les thèmes et les directions se développent au cours du roman. Chaque tableau que Crocquet met en scène, se rapporte aux tableaux précédents et suivants, élargit les paramètres des caractères du livre et enrichit notre monde. Dans chaque scène, chaque homme se construit par lui-même et laisse à l'observateur le sentiment, comme après une histoire réussie, d'un monde plus grand, un peu moins étrange, qu'il comprend plus mais connaît moins qu'auparavant.

Rick Wester

THE RECONNAISSANCE OF LIFE:
Photography by Pierre Crocquet de Rosemond

[Eugen Blume]

To this day, the question of when and why a photograph of the world becomes a work of art remains unanswered. Ever since a machine capable of capturing images of our surrounding reality was invented, we have lived with a sense that there is a "true" external image—not in a special, elite form, but as something that represents a chance to reassure ourselves on a mass scale about our immediate environment. In the meantime, there are probably billions of photographic images in this world, preserving all sorts of events, from ordinary to special, for posterity. How often family photo albums are opened up in the attempt to give memory the power of solid evidence. That's the way so-and-so looked: a person who has long since disappeared from the earth, but whose existence is proved by the photo. Countless lives not inscribed in history through special deeds are maintained in these private archives, as long as there is some kind of interest in them. In the old days, only the stories told about grandmother, uncle, or brother helped to retain the memory of them. Told by those still alive, who had witnessed their lives. The photograph goes far beyond this. It can also convey something about a life even when no one who remembers this life is left alive, when even the name of the person in the picture is unknown. Thousands of these photographs, having accidentally escaped destruction, can be found at flea markets, waiting for someone who will be interested in them, someone who, despite the anonymity of the person depicted, sees something in the photo that should be kept. In the meantime, there are now large collections of anonymous photographs that can provide no specific information—no names, no dates—about either the photographs or the people in them. Not every photograph finds its way into such a collection—only those that contain, in the eyes of the beholder, a quality beyond the ordinary. They have touched upon something normally ascribed to artistic photography—behind which, however, is always hidden an experienced subject, a well-known photographer. Here, we usually discover a different state, one that remains hidden to the naked eye until the photograph reveals it. Yet how do we reach this obviously different visual space? Do photographers regarded as artists have a sixth sense that distinguishes them from the masses who take photographs? In order to answer these questions, it is helpful to look at collections of anonymous photographs. They are free of any influence—a school of photography or a famous name, for instance: something that guarantees quality all by itself. Arguments made in defense of a photographic image have to be chosen carefully. To present this type of plea, it is necessary to make exacting observations—still the most important thing in the reception of photographs. It is precisely because we imagine that photographs reproduce reality, and thus are, apparently, the closest things to reality itself, that we have to examine them thoroughly.

South African photographer Pierre Crocquet de Rosemond, born in 1971 in Cape Town, became recognized for photographs whose unvarnished sense of reality demands just this of viewers. They should stay as long as possible in the space where his pictures hang,

looking at the faces and their surroundings, in order to become aware of what made them attractive in the first place, the ultimate reason for taking the picture. Yet it might be objected that looking at photographs is a matter of course. It could also be said that the motifs Crocquet finds, most of them in South Africa and Africa, are already so unusual that a European, for instance, would naturally want to take a closer look at these worlds of images. However, even a superficial observation starts to make it clear that Crocquet is not looking for African exoticism, but rather, for human life—a life that can no longer be confined to a single country. Everywhere around the world, it is at home in a similar way. Basically, it does not matter at all where Crocquet takes his photographs; he could have found similar motifs in almost every region on earth, including Europe.

Crocquet is not seeking to capture social strata in their different circumstances, reflected in physiognomies and their environments. Instead, he chronicles marginal lives and simple people who are susceptible to being forced suddenly into poverty. Occasionally, just a few undesired events, for which no one is to blame, are sufficient. The portraits are not titled, only numbered—suggesting that what is shown might refer to a general something beyond a specific life or place, turning life itself into a metaphor for a particular fate.

In image 2, depicting a man with a cat on his lap, we see a seemingly ordinary situation, certainly for this man. However, it is imperative to "read" the photograph more precisely, and it is at this point that the question arises of how many ways there might be to read it. If, for instance, this man's neighbor were to look at the photo, he might simply consider it a good, or maybe bad, likeness of his neighbor; he might also be able to tell us one or two episodes from this man's life; he might characterize him, judge him, or even remain indifferently silent. My perspective, which should not simply be turned into that of an outside eye, first sees the watery, bright eyes in a haggard, wrinkled face; the heavily lined forehead, the bags under the eyes, the sunken cheeks, the deep folds to the right and left of the straight nose, leading down to the still-beautiful, half-open mouth. The hair is thick and dark; the man's age is hard to guess. In this man's memory, the suffering articulated in his face is linked to events I know nothing about, but which have left behind deep, visible traces. The sofa upon which the man sits with his well-fed cat—perhaps the only creature who still seeks out his company and feels comfortable with him—is marked by time, like a repetition of his face. It might once have been a good piece of furniture, but it has long since frayed; the padding an upholsterer once placed under the fabric is exposed, like the insides of an open cadaver. It might be where the man sleeps; it might even be outdoors. Next to the two pillows on the outer left are three utensils, references to what he was doing before the photograph was shot—activities that will be taken up once again later: the full ashtray refers to the smoker; behind and to the left, the odd piece of leather with a wire handle is probably a fly swatter as well as a cat toy. The folded dark bag in front contains the tobacco the man uses to roll his own cigarettes. In an odd contrast to the items just described, his clothing is casually elegant; one corner of a white shirt collar projects from underneath an old sweater; a watch with a metal armband can be seen on his wrist; the hands, scarred by hard work, are helplessly bent, as if gouty; the left hand rests in his lap, holding the cat's tail—a gesture the cat is familiar with. There is something conciliatory about the equanimity of the animal also looking out of the picture. Animals seem imperturbable: they are not obsessed with their own fates, and know nothing of the disastrous relationships people have with each other, nothing of loneliness, nothing of unhappiness and downward social mobility, and this imperturbability is also comforting to the unnamed stranger in the photo. Crocquet has photographed this man several times: even once in a white striped shirt and neatly pressed trousers, hair combed, sitting on the edge of a grave. Image 30 suggests that this is probably the resting place of his father, one Matthys Johannes Nortje, who lived to be over eighty, and whose family, if I am right about the name, originally came from one of the northern European countries. A third photo, image 35, shows our man in profile, awakened from a nap by the gleaming light of the sun,

looking indifferently at the camera. The sofas, one of them by now familiar to us, are, in their torn state, memento moris, metaphors for death that seem to refer to the man, to a life that is now simply meaningless.

With his camera, Pierre Crocquet observes the sadness of the cemeteries, the human being's last resting place. Modern society's tastelessness degrades these once revered resting places, turning them into absurd collections of plastic chairs and party tents, a fake stage where last farewells are expressed. In image 47, the photographer stands behind the coffin in a narrow, bunkerlike chapel, guiding the eye past the wood to the desolate gravesite. A moving image of young men in white shirts, their jackets draped over a headstone, shoveling dirt into the open grave into which the coffin has just been lowered, lacks any trace of sorrow at first glance; then one spots the group of three people behind and to the right, crying over the departed (49). Obviously, the ambivalence of events, the presence of opposites, are things the photographer seeks.

Motifs selected by the photographer are varied, not simply taken from the sad sides of life. He is not looking for the cheap sensation, the original image, but for human life. Both young and old people appear in his pictures, and the secret of life is reflected in their faces. The well-fed, self-satisfied young woman in 38 is one of them, as is the elderly lady with the white hair in 13. The people in the photographs almost always look into the camera—directly at the viewer. These are not staged scenes, not strangers moving around in front of the camera; they are impressive portraits that capture personality in a convincing way. The photographer is rewarded with the rare moment in which something is concentrated in the gaze, in the face, permitting the viewer to look deep into the soul of the other, so that for a brief moment, his very private secrets are exposed to the eyes of strangers. It is always about human beauty, even when a person's fate has been terrible. An amputee, his legs cut off to his hips, sitting in a wheelchair in front of a clothesline upon which jeans that could not be his own are drying, conveys his proud determination not to give up.

Pierre Crocquet de Rosemond empathizes with the people he photographs. He observes their shortcomings, their hard lives, and their strength. Never does he compromise their existence, even when shooting things that are absurd, surreal—like the woman at her morning coffee, next to a pig's head in a bowl. His images are not ideological; they do not assume any sort of perspective. Instead, he leaves it up to the viewer to decide how to look at them. Everything is spread out in front of him: a tale about life, naturally sharp down to the last fold, from which one cannot easily pull away.

Eugen Blume is the director of the Hamburger Bahnhof—Museum für Gegenwart—Berlin.

DIE ERKUNDUNG DES SEINS:

Fotografien von Pierre Crocquet de Rosemond

[Eugen Blume]

Die Fragen, wann ein fotografisches Abbild der Welt zu einem Kunstwerk avanciert und warum, sind bis heute ungeklärt. Seit der Erfindung einer Apparatur, die Bilder der uns umgebenden Wirklichkeit festzuhalten versteht, leben wir in dieser Sensation eines »wahren« Außenbildes, und zwar nicht als elitäre Sonderform, sondern als massenhafte Möglichkeit, sich der nächsten Umgebung zu versichern. Es mag in dieser Welt inzwischen Milliarden fotografische Bilder geben, die banale, besondere oder gleich welche Ereignisse für die Ewigkeit konserviert haben. Wie oft werden die Familienalben geöffnet, um der Erinnerung eine unumstößliche Beweiskraft zu verleihen. So hat der und der ausgesehen, eine Person, die längst von der Erde verschwunden ist, deren Existenz aber das Foto beweist. Die unzähligen Biografien, die sich nicht durch besondere Taten in das Gedächtnis der Geschichte eingeschrieben haben, bleiben in diesen privaten Archiven so lange erhalten, wie es noch ein irgendwie geartetes Interesse für sie gibt. Früher waren es allein die Erzählungen, die an die Großmutter, den Onkel oder Bruder erinnerten. Vorgetragen von noch lebenden Zeugen dieser Existenzen. Die Fotografie reicht weit darüber hinaus. Sie vermittelt auch dann noch etwas über ein Leben, wenn es keine Zeugen dieser Biografie mehr gibt, selbst noch, wenn nicht einmal mehr der Name des abgelichteten Menschen bekannt ist. Auf Trödelmärkten finden sich Tausende Fotografien, die durch Zufall der Vernichtung entgangen sind und die auf einen Interessenten warten, der trotz ihrer Anonymität etwas in ihnen entdeckt, das er bewahrt wissen will. Inzwischen gibt es große Sammlungen von anonymen Fotografien, die weder über den Fotografen noch über die Dargestellten irgendetwas Präzises wie Name oder Entstehungszeit aussagen können. Nicht jede Fotografie findet Eingang in solche Konvolute, sondern nur die, die durch irgendetwas im Urteil des Betrachters über das Banale hinausgehen. Sie haben etwas berührt, was wir normalerweise der künstlerischen Fotografie zuordnen, hinter der sich allerdings immer ein erfahrenes Subjekt verbirgt, ein bekannter Fotograf. Hier finden wir gewöhnlich den anderen Zustand einer Welt, der unserem bloßen Auge verborgen bleibt, den erst das Abbild sichtbar macht. Wie aber gelingt es, diesen offenbar anderen Bildraum zu erreichen? Haben Fotografen, die wir als Künstler verstehen, einen anderen Sinn, der sie von der Masse der Fotografierenden unterscheidet? Um diese Fragen zu beantworten, ist es hilfreich, Sammlungen von anonymen Fotografien zu betrachten. Sie sind frei von jedem Einfluss, etwa dem einer fotografischen Schule oder eines berühmten Namens, der allein schon für Qualität bürgt. Die Argumente der Verteidigung eines fotografischen Bildes müssen schärfer gewählt werden. Das Plädoyer zwingt zu einer genauen Betrachtung, die immer noch das Wichtigste in der Rezeption von Fotografien ist. Gerade weil Fotografien in unserer Vorstellung Wirklichkeit ablichten und damit der Wahrheit scheinbar am nächsten kommen, müssen wir sie eingehend studieren.

Der südafrikanische, 1971 in Kapstadt geborene Fotograf Pierre Crocquet de Rosemond ist mit Fotografien bekannt geworden, die in ihrem ungeschminkten Wirklichkeitssinn genau das von dem Betrachter verlangen. Er soll möglichst lange in den Raum seiner Bilder hineinsehen, die Gesichter und deren Umwelt betrachten, um auf das zu stoßen, was ihn selbst angezogen hat, was letztlich der auslösende Grund seiner Aufnahme war. Nun mag man einwenden, dass es selbstverständlich ist, Fotografien zu betrachten. Möglicherweise könnte man auch sagen, die Motive, die Crocquet meistens in Südafrika und Afrika findet, sind schon so außergewöhnlich, dass etwa ein Europäer selbstverständlich genauer in diese Bildwelten hineinsieht. Was aber schon bei einer oberflächlichen Betrachtung klar zu werden beginnt ist, dass Crocquet nicht den afrikanischen Exotismus sucht, sondern die menschliche Existenz, eine Existenz, die nicht mehr auf ein Land festlegbar ist. Sie ist in ähnlicher Daseinsweise überall auf der Welt zu Hause. Im Grunde ist es völlig gleichgültig, wo Crocquet fotografiert, gleiche Motive hätte er in fast allen Ländern dieser Erde, Europa eingeschlossen, finden können.

Crocquet ist nicht unterwegs, die sozialen Schichten in ihren unterschiedlichen, sich in den Physiognomien und ihrer Umgebung spiegelnden Zuständen festzuhalten, sondern er ist ein Chronist der Randexistenzen und einfachen Leute, die schnell in die Armut gedrängt werden können. Mitunter genügen nur wenige Ereignisse, von niemand gewollt und von niemand verschuldet. Die Porträts tragen keine Titel, sondern Nummern, die suggerieren, das zu Sehende könnte über die konkrete Biografie oder den konkreten Ort hinaus in etwas Allgemeines weisen, das Leben selbst zur Metapher eines bestimmten Schicksals werden lassen.

Auf der Schwarz-Weiß-Fotografie 2 sehen wir einen Mann mit einer Katze auf dem Schoß, scheinbar ist hier eine alltägliche Situation festgehalten, und für diesen Mann ist sie es ganz sicherlich. Nun ist der Augenblick gekommen, die Fotografie genauer zu »lesen«, und spätestens hier stellt sich die Frage, wie viele Lesarten es wohl geben mag. Würde etwa der Nachbar dieses Mannes das Foto betrachten, würde er vielleicht nur meinen, sein Nachbar sei gut oder nicht gut getroffen und möglicherweise könnte er eine oder mehrere Episoden aus dem Leben dieses Menschen erzählen, ihn charakterisieren, ihn beurteilen oder auch gleichgültig schweigen. Mein Blick, der sich hier nicht in einem fremden »man« auflösen soll, sieht zunächst die wasserhellen Augen in einem hageren, durchfurchten Gesicht, die faltenschwere Stirn, die Säcke unter den Augen, die eingefallenen Wangen, die tiefen Falten rechts und links von der geraden Nase zu dem noch immer schönen, halbgeöffneten Mund hinunter. Die Haare sind dicht und dunkel, das Alter dieses Mannes ist schwer zu schätzen. Die Qual, die aus diesem Gesicht spricht, verbindet sich in der Erinnerung dieses Mannes mit Ereignissen, die ich nicht kenne, die aber tiefe, sichtbare Spuren hinterlassen haben. Das Sofa, auf dem der Mann mit seiner wohlgenährten Katze sitzt – vielleicht das einzige Lebewesen, das noch seine Nähe sucht und sich bei ihm wohlfühlt –, ist wie eine von der Zeit gezeichnete Wiederholung seines Gesichtes. Einst mag es ein gutes Möbel gewesen sein, inzwischen ist es zerfetzt; die einstmals von einem Polsterer unter den Stoff gelegte Unterfütterung liegt wie das Innere eines offenen Kadavers frei. Es mag die Schlaffläche des Mannes sein, vielleicht steht es sogar im Freien. Neben den zwei Kissen links außen sind es drei Utensilien, die auf die dem feststellenden Blick der Fotografie vorausgegangenen und später wieder aufgenommenen Handlungen verweisen: der gefüllte Aschenbecher auf den Raucher, das eigenartige Lederteil mit einem Draht als Stil links dahinter ist wohl eine Insektenklatsche und zugleich ein Spielzeug für die Katze. Der gefaltete dunkle Beutel vorne enthält den Tabak, der Mann dreht sich die Zigaretten selbst. Seine Kleidung ist in einem seltsamen Gegensatz zu dem Beschriebenen von einer legeren Eleganz, das weiße Hemd ragt mit einer Kragenecke aus dem übergezogenen, abgenutzten Pullover, am Handgelenk ist eine Uhr mit metallenem Armband zu sehen, die Hände, von schwerer Arbeit gekennzeichnet, sind nach innen wie unter der Gicht kraftlos gekrümmt, die Linke ruht im Schoß und hält den Schwanz der Katze, eine ihr vertraute Geste. Der Gleichmut des Tieres, das ebenfalls aus dem Bild heraussieht, hat etwas Versöhnendes. Die Unerschütterlichkeit der animalischen

Spezies, die sich nicht im eigenen Schicksal verzehrt, sondern überhaupt nichts weiß von den verhängnisvollen Beziehungen, die Menschen untereinander eingehen, nichts von der Einsamkeit, nichts von Unglück und sozialem Abstieg, ist hier der Trost auch dieses ungenannten Fremden. Crocquet hat diesen Mann mehrfach fotografiert, einmal sogar im weißen gestreiften Hemd mit gebügelter Hose und gekämmten Haar auf dem Rand eines Grabes sitzend. Die Fotografie 30 deutet an, dass hier möglicherweise sein Vater ruht, ein Matthys Johannes Nortje, der über 80 Jahre alt geworden ist und dessen Familie, wenn ich den Namen richtig deute, ursprünglich aus einem der nordischen Länder Europas stammte. Ein drittes Foto, 35, zeigt unseren Mann von der Seite, wie er getroffen von dem gleißenden Licht der Sonne – gerade aus einem Tagesschlaf erwacht – gleichgültig in die Kamera sieht. Die Sofas, ein uns inzwischen vertrautes Mobiliar, sind in ihrer Verschlissenheit Memento mori, Todesmetaphern, die sich auf den Mann, auf das nur noch sinnlose Leben zu beziehen scheinen.

Pierre Crocquet beobachtet mit seiner Kamera die Tristesse der Friedhöfe, die letzten Orte der menschlichen Existenz. Die Geschmacklosigkeiten der modernen Gesellschaft lassen diese einstmals geheiligten Ruhestätten zu absurden Versammlungen von Plastiksesseln und Partyzelten, zu einer falschen Kulisse eines letzten Abschieds verkommen. In 47 steht der Fotograf hinter dem Sarg in einer engen, bunkerartigen Einsegnungshalle und richtet den Blick über das Holz hinaus auf den trostlosen Begräbnisort. Das bewegte Bild, auf dem junge Männer in weißen Hemden, die Jacken über einen Grabstein gelegt, die offene Grube, in die gerade der Sarg gesenkt wurde, zuschaufeln, ist auf den ersten Blick ohne jede Spur von Trauer, würde man nicht die Gruppe von drei Menschen rechts hinten entdecken, die um den Verstorbenen weinen (49). Diese Ambivalenz der Geschehnisse, die Anwesenheit der Gegensätze ist etwas, wonach der Fotograf offenbar sucht.

Die Motive, die der Fotograf wählt, sind unterschiedlich und nicht nur den traurigen Seiten des Lebens entnommen. Er sucht nicht die billige Sensation, das originelle Bild, sondern das Sein des Menschen. In seinen Bildern finden sich junge und alte Menschen, in deren Gesichtern sich das Geheimnis des Lebens spiegelt. Die wohlgenährte, mit sich zufriedene junge Frau in der Fotografie 38 gehört ebenso dazu wie die alte Dame mit dem weißen Haar in 13. Die abgebildeten Personen sehen fast immer in die Kamera, also den Betrachter direkt an. Es sind keine gestellten Szenerien, sich vor dem Apparat fremd bewegender Menschen, sondern eindrückliche Porträts, die überzeugend die Persönlichkeit erfassen. Dem Fotografen ist der seltene Moment geglückt, in dem sich im Blick, im Gesicht etwas konzentriert, das tief in die Seele des anderen blicken lässt, für einen kurzen Augenblick sein ganz persönliches Geheimnis den Augen des Fremden ausliefert. Immer geht es um die Schönheit des Menschen, auch dort, wo er in ein schweres Schicksal geraten ist. Der bis zu den Hüften Amputierte im Rollstuhl vor einer Wäscheleine mit trocknenden Jeans, die nicht seine sein können, vermittelt den stolzen Mut, nicht aufgeben zu wollen.

Pierre Crocquet de Rosemond fühlt mit den Menschen, die er fotografiert. Er sieht ihre Unzulänglichkeiten, ihr hartes Los und ihre Kraft. Niemals desavouiert er ihr Dasein, auch dann nicht, wenn ihm absurde, surreale Einstellungen gelingen, wie die der Frau beim Morgenkaffee mit einem Schweinskopf in der Schüssel. Seine Bilder sind nicht ideologisch, setzen keine Sicht voraus, sondern überlassen dem Betrachter die Entscheidung, wie er sie sehen will. Vor ihm ist alles ausgebreitet, unverstellt scharf bis in die letzte Falte hinein ein Lebensbericht, dem man sich nicht leicht entziehen kann.

Eugen Blume ist Leiter des Hamburger Bahnhof – Museum für Gegenwart – Berlin.

L'EXPLORATION DE L'EXISTENCE :

Photographies de Pierre Crocquet de Rosemond

[Eugen Blume]

Savoir quand et pour quelles raisons une photographie devient une œuvre d'art sont des questions qui restent aujourd'hui encore sans réponse. Depuis l'invention d'un appareil capable de fixer les images de la réalité nous entourant, nous vivons dans cette sensation d'une image extérieure « réelle », non pas sous une forme spéciale et élitiste, mais comme possibilité offerte au grand public de se rassurer sur la présence de son environnement proche. Il existe maintenant des milliards de photographies qui ont fixé pour l'éternité des événements banals, spéciaux ou anodins. Combien de fois a-t-on ouvert des albums de famille pour rendre l'évocation d'un souvenir plus convaincante ? Voilà à quoi ressemblait un tel, quelqu'un qui, bien souvent, n'est plus de ce monde depuis longtemps mais dont la photo prouve l'existence. Les innombrables biographies qui ne se sont pas inscrites dans les mémoires pour des actes hors du commun demeurent dans ces archives privées aussi longtemps que perdure un quelconque intérêt. Autrefois on se contentait de récits réveillant le souvenir de la grand-mère, de l'oncle ou du frère ; récits relatés par des témoins encore vivants de ces existences. La photographie, elle, va bien au-delà. Elle continue à transmettre des informations sur une vie, longtemps après que tous les témoins vivants ont disparu et même lorsque le nom de la personne photographiée n'est pas connu. Dans de nombreuses brocantes, on peut trouver des milliers de photographies qui, par hasard, ont échappé à la destruction et qui attendent l'intérêt d'une personne qui découvrira en elles, en dépit de leur anonymat, une part qu'elle veut préserver. Il existe désormais d'importantes collections de photos anonymes qui ne nous donnent aucune précision concernant le photographe ou les personnes représentées : ni dates, ni noms. Ce n'est pas le lot de chaque photographie de pouvoir ainsi sortir de l'oubli, mais uniquement de celles qui, au regard de leur acquéreur, sortent de l'ordinaire. Elles ont touché ce que l'on attribue d'habitude à la photographie artistique derrière laquelle se cache toujours un sujet averti, un photographe connu. On y trouve habituellement l'autre vision du monde, celle invisible à nos yeux et que seule la photo nous permet enfin de découvrir. Mais comment peut-on atteindre cet espace manifestement différent ? Est-ce que les photographes que nous considérons comme des artistes possèdent une autre sensibilité qui les différencie de la masse de personnes prenant des photos ? Pour répondre à ces questions, il est utile d'observer des collections de photographies anonymes. Elles sont exemptes de toute influence qui pourrait garantir une certaine qualité, qu'il s'agisse de celle d'une école de photographie ou d'un nom connu. Les arguments pour valoriser de telles photographies doivent être choisis avec plus de précision. Leur défense oblige à avoir une observation poussée qui prend une place prépondérante dans la réception de photographies. C'est justement parce que, pour nous, les photos doivent représenter la réalité et pour cela en être le plus proche possible qu'on doit les étudier en détail.

Pierre Crocquet de Rosemond, photographe sud-africain né au Cap, s'est rendu célèbre grâce à des photographies dont le réalisme dépourvu de tout artifice provoque cette réaction de la part de leurs observateurs. On doit regarder aussi longtemps que possible dans l'espace de ses tableaux, observer les visages et leur environnement pour comprendre ce qui l'a lui-même attiré, ce qui a déclenché sa photo. On pourrait objecter que cette observation relève de l'évidence. On pourrait également ajouter que les thèmes choisis par Crocquet, puisés le plus souvent en Afrique du Sud ou dans le reste de l'Afrique, sortent tant du commun qu'un Européen est obligé d'étudier ces univers photographiques avec précision. Une première observation superficielle révèle que Crocquet ne recherche pas l'exotisme africain mais l'existence humaine, une existence qui ne soit pas fixée en fonction d'un pays. Il s'agit d'une existence qui se sent chez elle dans quelque endroit du monde que ce soit. Au final, Crocquet aurait pu faire les mêmes clichés partout, y compris en Europe.

Crocquet n'essaie pas de fixer les couches sociales reflétées dans des états divers à travers leur physionomie et leur environnement, mais il est le chroniqueur d'existences marginales et de gens simples toujours à la limite de la pauvreté. Parfois il leur suffit d'un événement que personne n'a voulu ou n'a provoqué pour y sombrer. Les portraits ne portent pas de titres mais seulement des numéros qui suggèrent que ce qui est donné à voir peut s'étendre au-delà du récit d'une vie ou d'un lieu concret à quelque chose de plus général et faire de la vie elle-même une métaphore d'un destin défini.

La photo 2 représentant un homme portant un chat sur ses genoux fixe apparemment une situation quotidienne de la vie de cet homme. C'est à ce moment qu'il faut déchiffrer plus en profondeur cette photo et c'est au plus tard à ce moment-là que l'on se demande combien il peut y avoir de lectures. Si le voisin de cet homme regarde cette photo, il pensera peut-être tout simplement qu'elle est plus ou moins réussie et éventuellement il pourra raconter quelques anecdotes sur la vie de cet homme, en dresser un portrait, le juger ou tout simplement garder le silence avec indifférence. Mon regard, qui ne doit pas ici se mêler à un « on » étranger, voit tout d'abord les yeux très clairs dans un visage maigre et émacié, le front ridé, les poches sous les yeux, les joues tombantes, les rides plus marquées à droite et à gauche du nez droit descendant jusqu'à la bouche, à moitié ouverte et encore belle. Les cheveux sont épais et foncés, il est difficile de donner un âge à cet homme. La douleur qui émane de ce visage s'associe dans le souvenir de cet homme à des événements qui me sont inconnus mais qui ont laissé des traces profondes et visibles. Le canapé sur lequel il est assis en compagnie de son chat, visiblement bien nourri – peut-être le seul être à encore chercher sa présence et qui se sente bien auprès de lui – semble faire écho à son visage et à la marque du temps. Ce fut certainement un bon meuble mais à présent il est déchiqueté ; le rembourrage autrefois contenu dans les coussins et sous l'étoffe gît à l'air libre comme l'intérieur d'un cadavre ouvert. C'est peut-être là que dort l'homme, peut-être même en plein air. Près des coussins sur la partie gauche, trois ustensiles sont posés. Ils évoquent les actions interrompues par le regard figé de la photographie : le cendrier plein du fumeur, l'étrange morceau de cuir monté sur un fil de fer posé derrière le cendrier qui est un tue-mouche et en même temps un jeu pour le chat et la petite poche foncée repliée qui contient du tabac et qui nous indique que l'homme se roule ses cigarettes. Sa tenue, en contradiction étrange avec le reste de la scène, est d'une élégance décontractée, un coin du col de sa chemise blanche dépasse de son pull rapiécé, il porte au poignet une montre au bracelet métallique, les mains, marquées par le travail, sont repliées vers l'intérieur, sans force, comme si elles souffraient d'arthrite, la gauche posée sur ses genoux tient la queue du chat, geste auquel l'animal semble habitué. L'impassibilité de ce dernier qui fixe aussi l'objectif a quelque chose d'apaisant. L'imperturbabilité de l'espèce animale, qui n'est pas obsédée par son propre destin et qui ne connaît rien des relations néfastes entretenues par les hommes, rien de la solitude, rien du malheur et de la déchéance sociale, est ici la consolation de cet étranger sans nom.

Crocquet a photographié cet homme à plusieurs reprises, une fois notamment portant une chemise blanche à rayures et un pantalon repassé, les cheveux peignés, assis sur le bord d'une tombe. Cette photo 30 nous fait penser qu'il s'agit vraisemblablement de la tombe de son père, un dénommé Matthys Johannes Nortje, mort à presque 81 ans et dont la famille, d'après le nom, doit être originaire d'un pays d'Europe du Nord. Une troisième photo, 35, le représente de profil, au réveil d'une sieste, baigné dans la lumière éblouissante du soleil et fixant indifféremment l'objectif. Le mauvais état des canapés, mobilier qui nous est à présent familier, est un memento-mori, une métaphore de la mort qui se réfère à l'homme et à une vie désormais dénuée de sens.

À travers son objectif, Pierre Crocquet observe la tristesse des cimetières, derniers lieux de l'existence humaine. L'irrévérence de la société moderne transforme ces demeures autrefois sacrées en une réunion absurde de chaises en plastique sous une tente de fête, les rabaissant au faux décor d'un dernier adieu. Pour la photo 47, le photographe se place derrière un cercueil, dans une salle, exiguë et sombre comme un bunker, faisant office de chapelle, et dirige son objectif au-dessus du cercueil en bois sur un paysage désolé de tombes. Le tableau en mouvement sur lequel de jeunes hommes en chemise blanche, leurs vestes posées sur une pierre tombale, sont en train de remblayer la fosse dans laquelle on vient de descendre le cercueil, semble au premier abord dénué de tout sentiment de deuil. Seule la découverte d'un groupe de trois personnes pleurant leur mort dans le fond à droite lui confère cette gravité (49). Cette ambivalence dans les actions, la présence de ces oppositions sont manifestement des choses que le photographe recherche.

Les motifs choisis par le photographe sont divers et ne s'inspirent pas uniquement des aspects dramatiques de la vie. Il ne cherche pas la sensation bon marché ou le tableau original mais l'essence de l'homme. Dans ses tableaux se trouvent des personnes jeunes et plus âgées dont les visages reflètent le mystère de la vie. La jeune femme replète de la photo 38 qui pose avec une certaine autosatisfaction tout comme la vieille dame aux cheveux blancs de la photo 13 en font partie. Les personnes photographiées fixent presque toujours l'objectif et le spectateur. Il n'y a pas de scénario mettant en scène des étrangers en mouvement devant l'appareil mais des portraits vivants, qui saisissent les personnalités de façon convaincante. Le photographe a réussi à saisir le moment unique pendant lequel se concentre, dans le regard et dans le visage, quelque chose qui nous laisse pénétrer au plus profond de l'âme de cet autre qui livre son secret le plus intime au regard d'un inconnu. Il s'agit toujours de la beauté de l'homme même lorsqu'il a sombré dans un destin difficile. L'homme en fauteuil roulant amputé au niveau des hanches devant la corde à linge sur laquelle sèchent des jeans qui ne peuvent être les siens transmet sa fière détermination à ne pas se résigner.

Pierre Crocquet de Rosemond a de la compassion pour les êtres qu'il photographie. Il cible leurs manques, leur triste sort et leur force. Il ne blâme jamais leur existence même lorsqu'il saisit des scènes absurdes et surréelles, comme celle de cette femme buvant son café, une tête de porc posée dans le saladier devant elle. Ses photos ne sont pas idéologiques, elles n'imposent pas une vision mais laissent au spectateur le choix de décider de quelle manière il veut les voir. Tout est mis sous ses yeux avec netteté et précision : jusqu'à la dernière ride, le récit d'une vie à laquelle on ne peut échapper.

Eugen Blume est directeur de la Hamburger Bahnhof – Museum für Gegenwart – Berlin.

[ENTER]

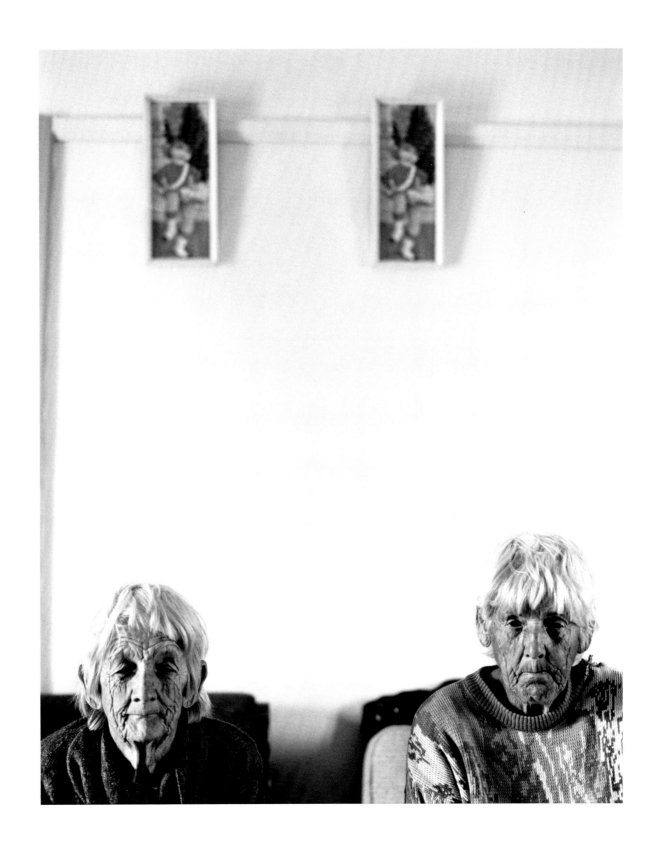

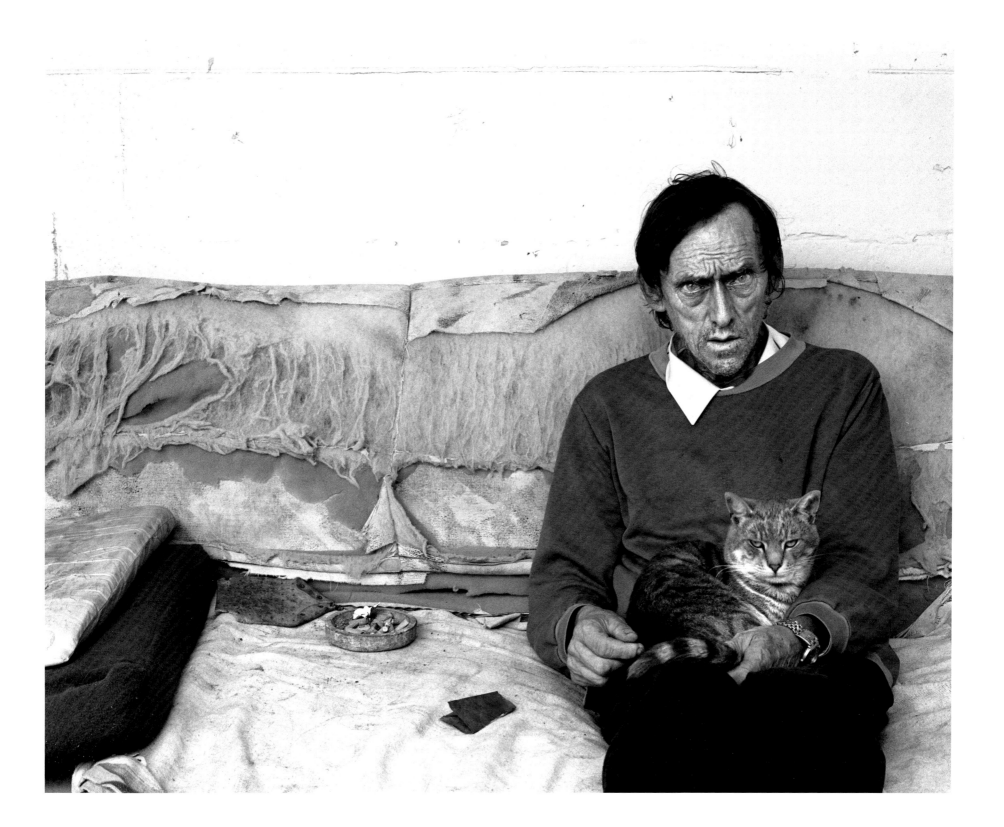

[3] 2 0 0 6

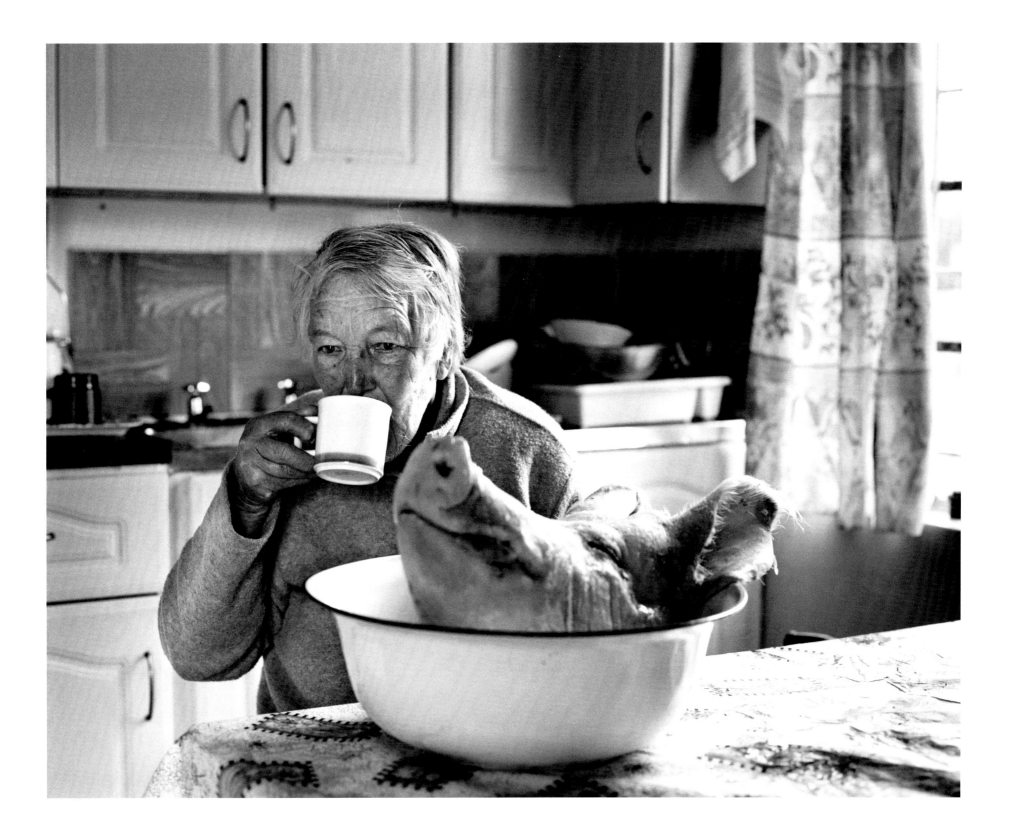

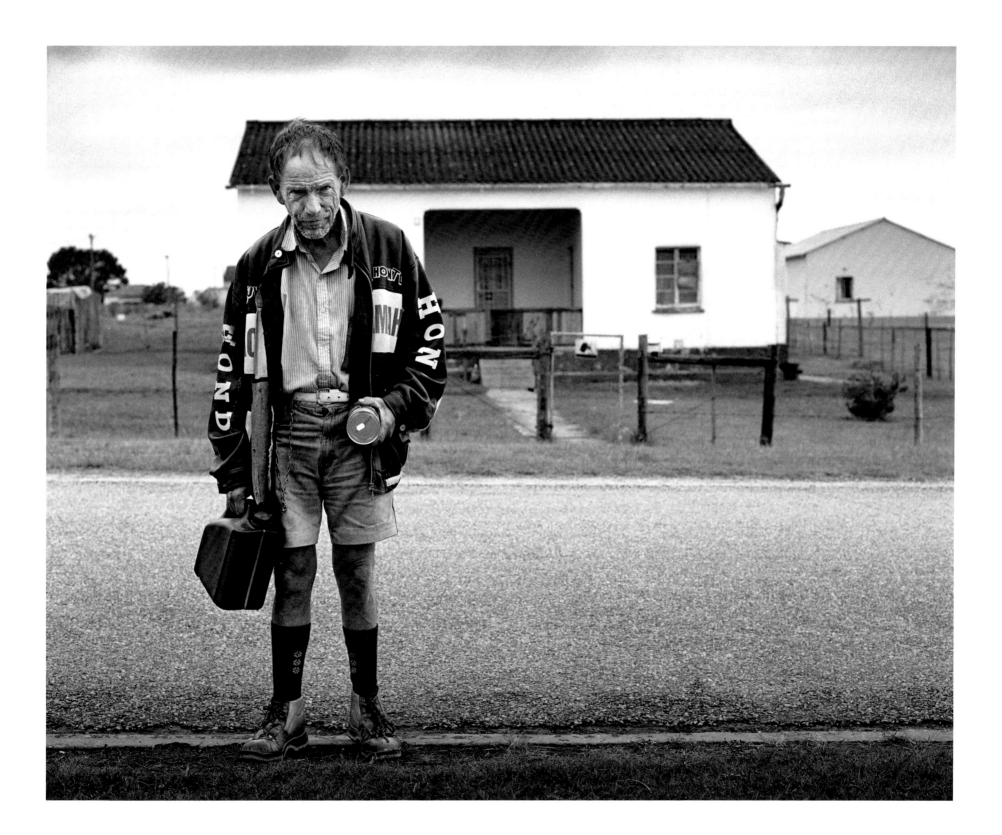

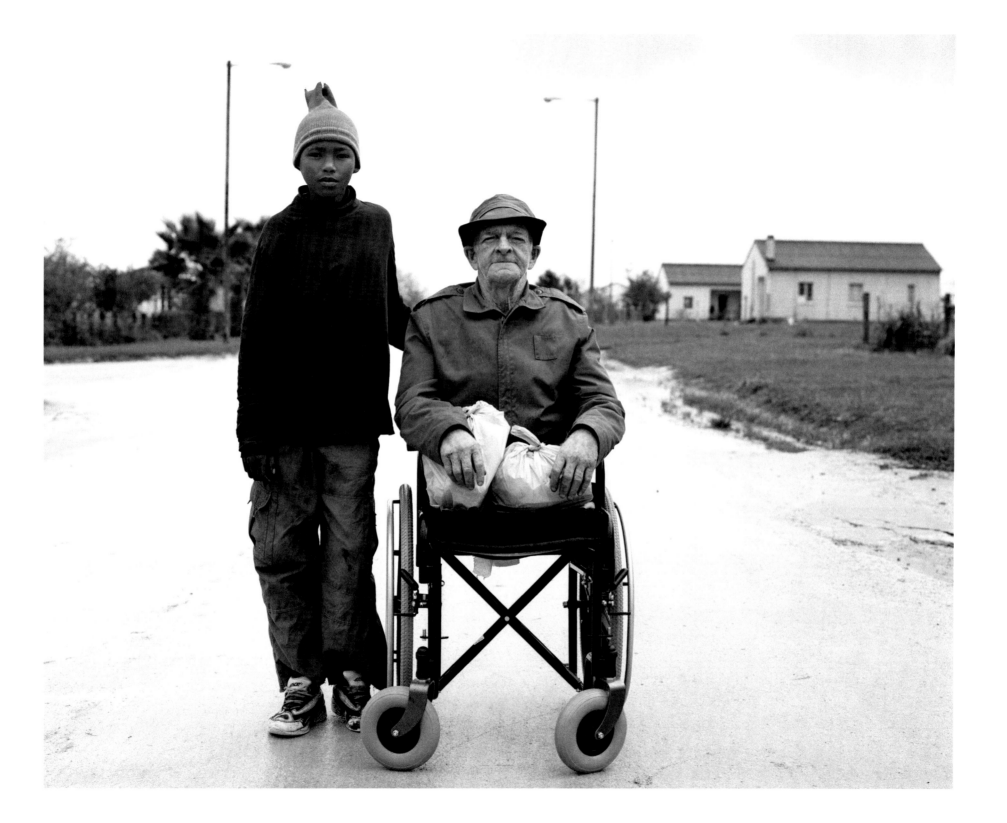

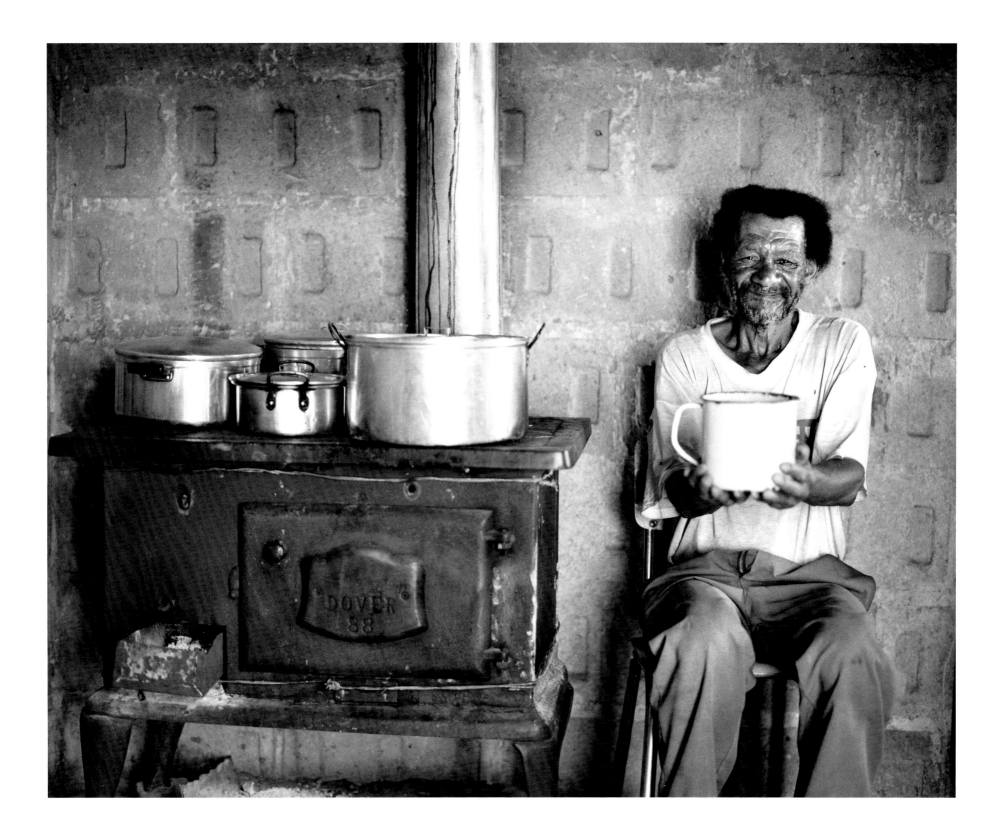

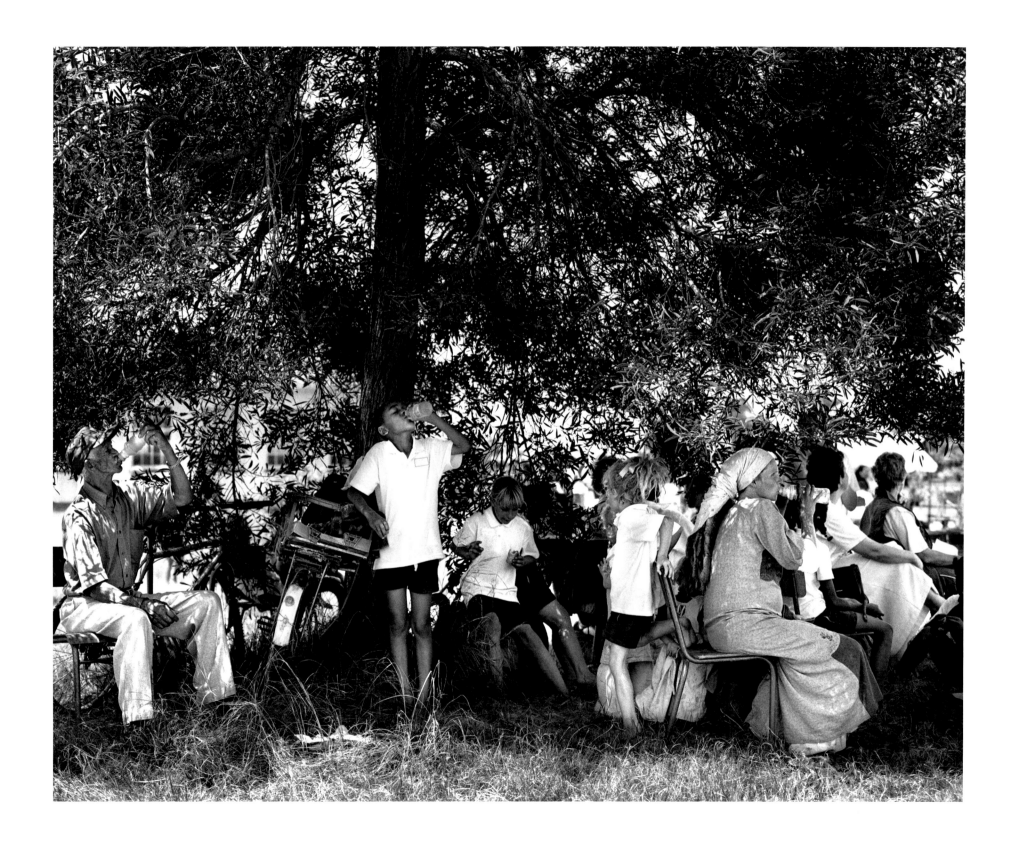

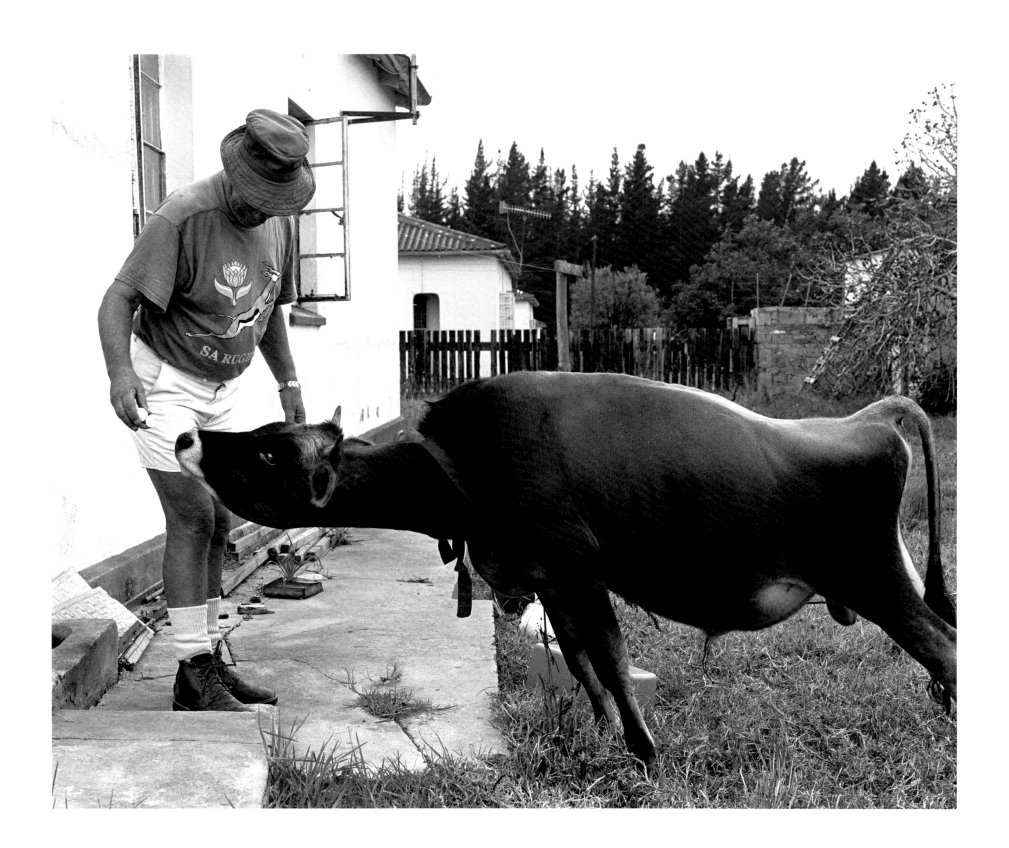

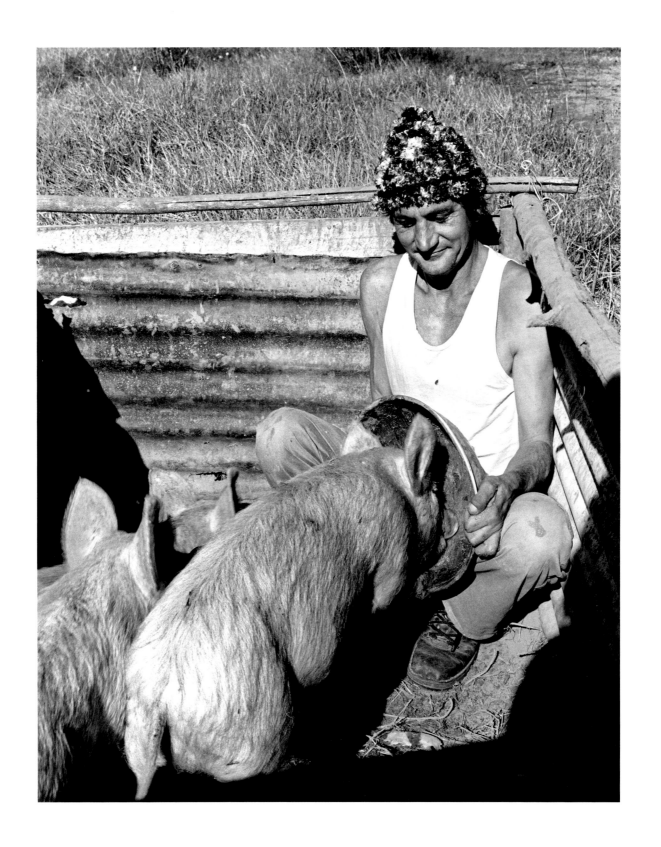

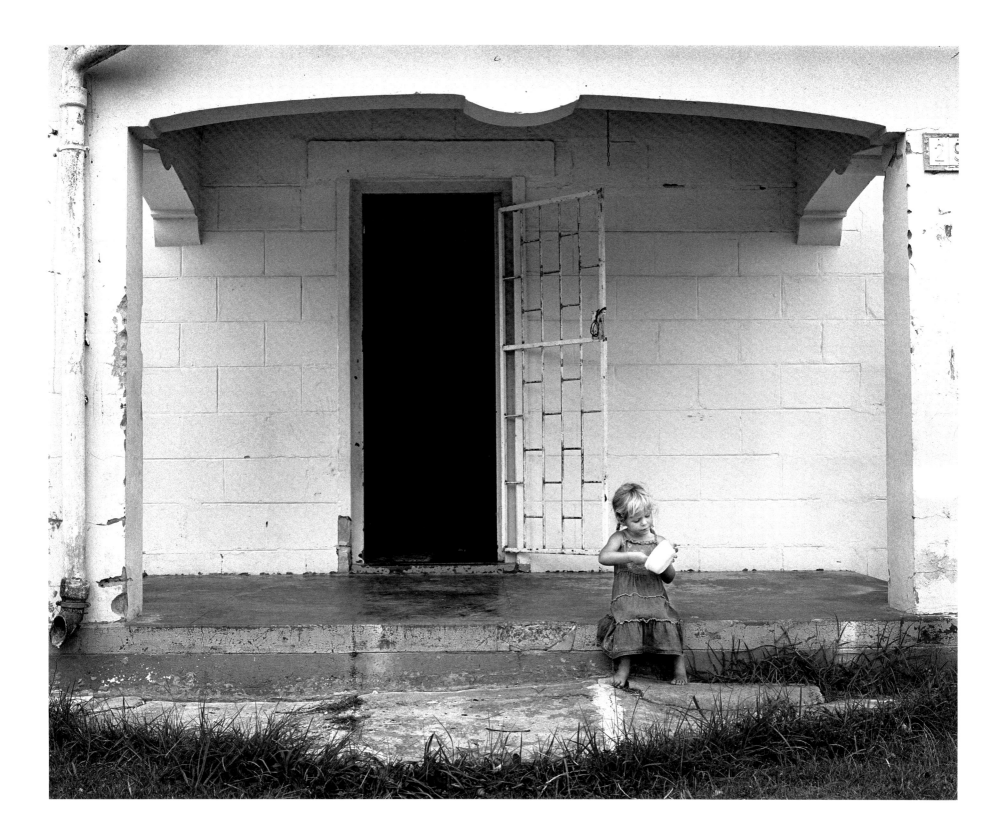

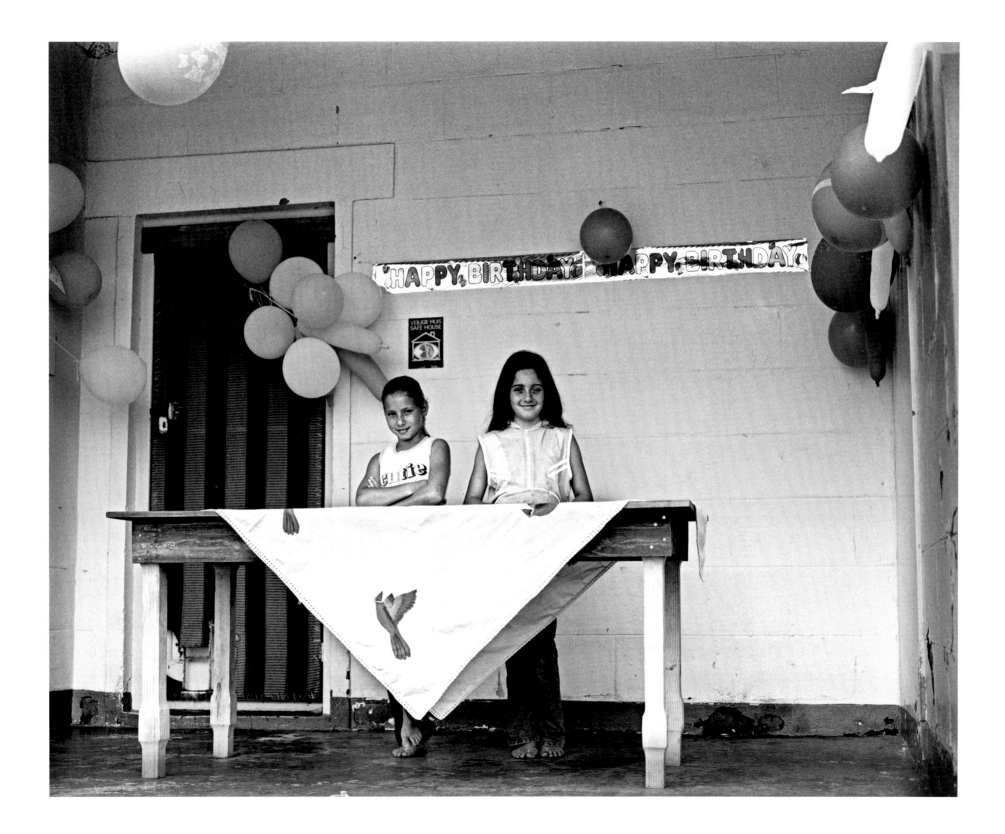

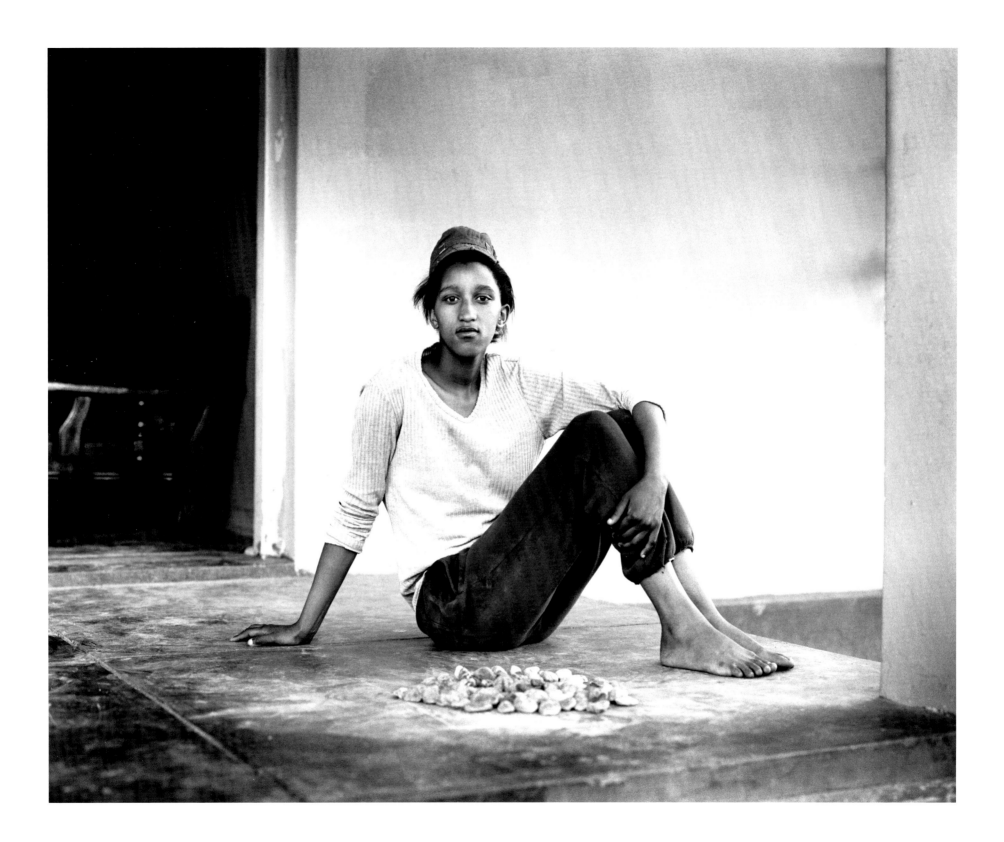

[13] 2 0 0 6

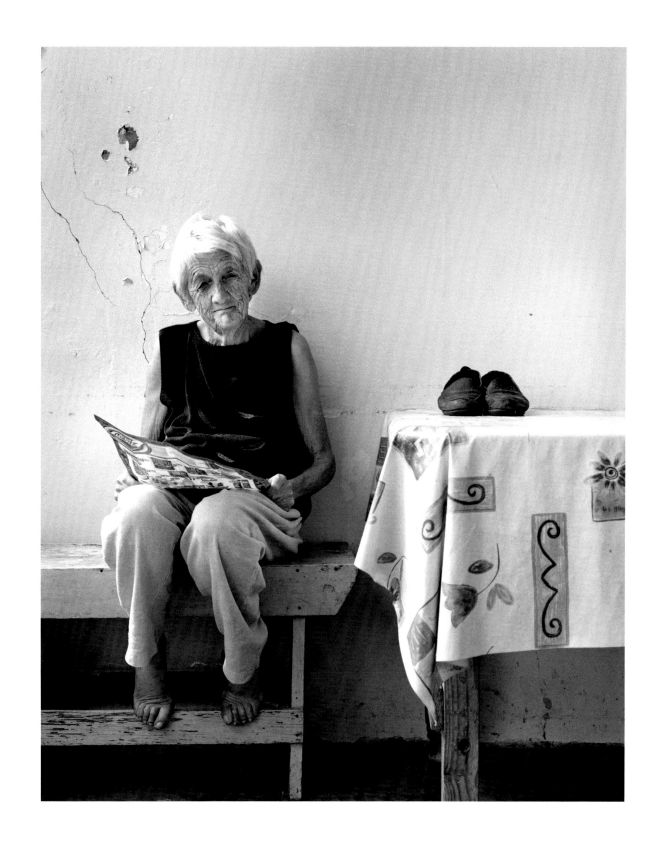

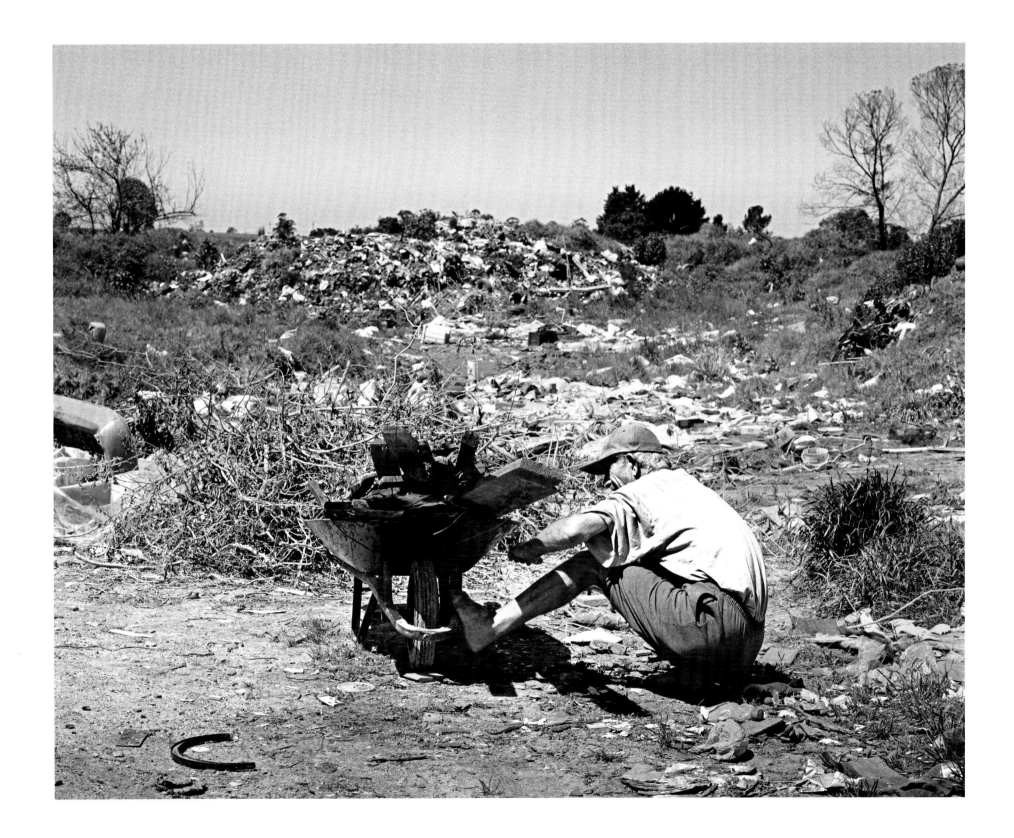

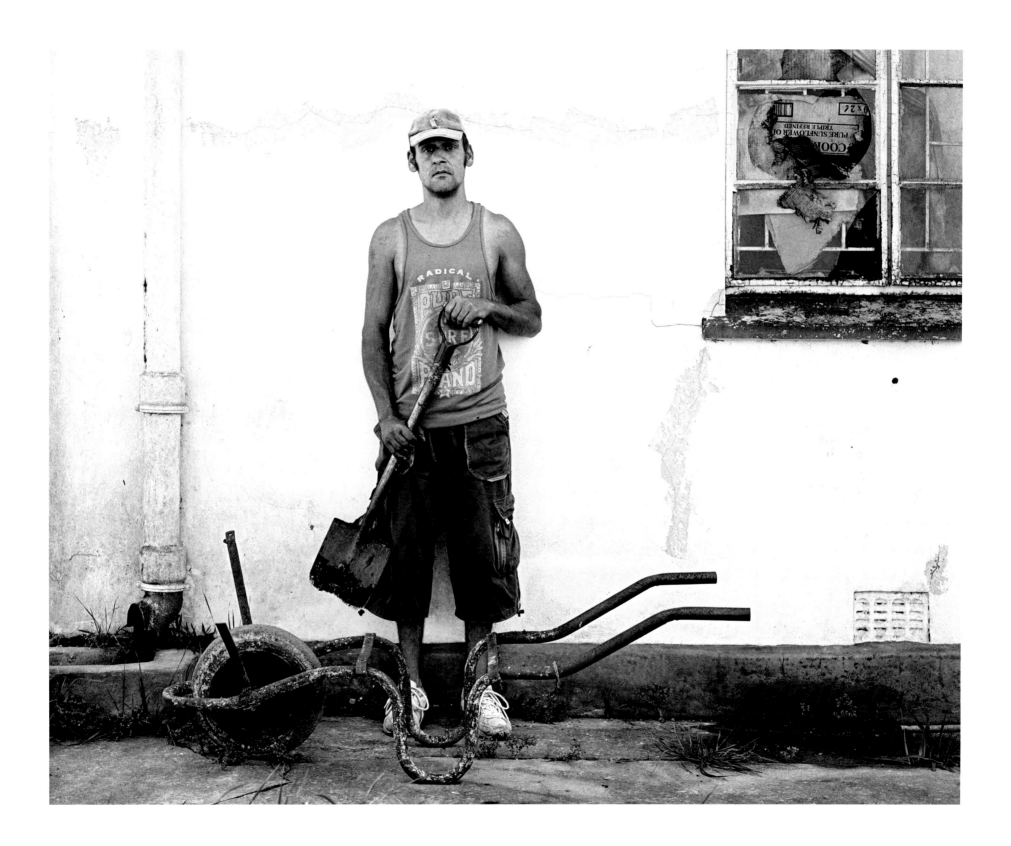

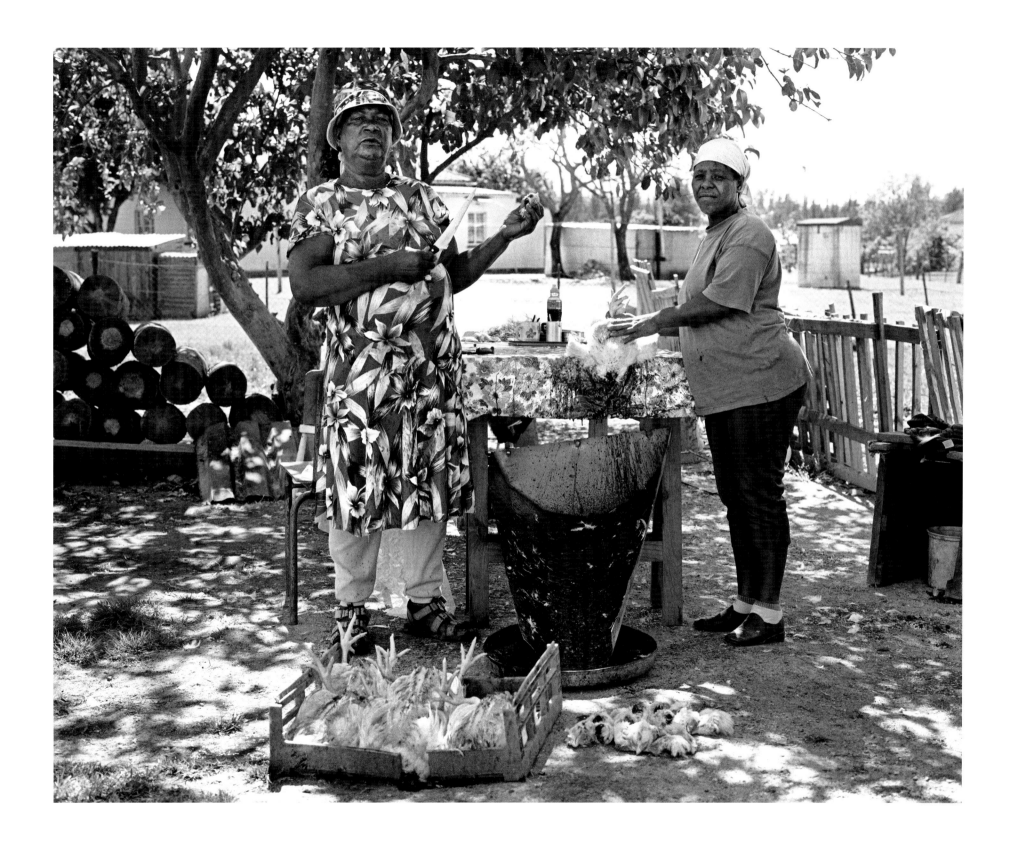

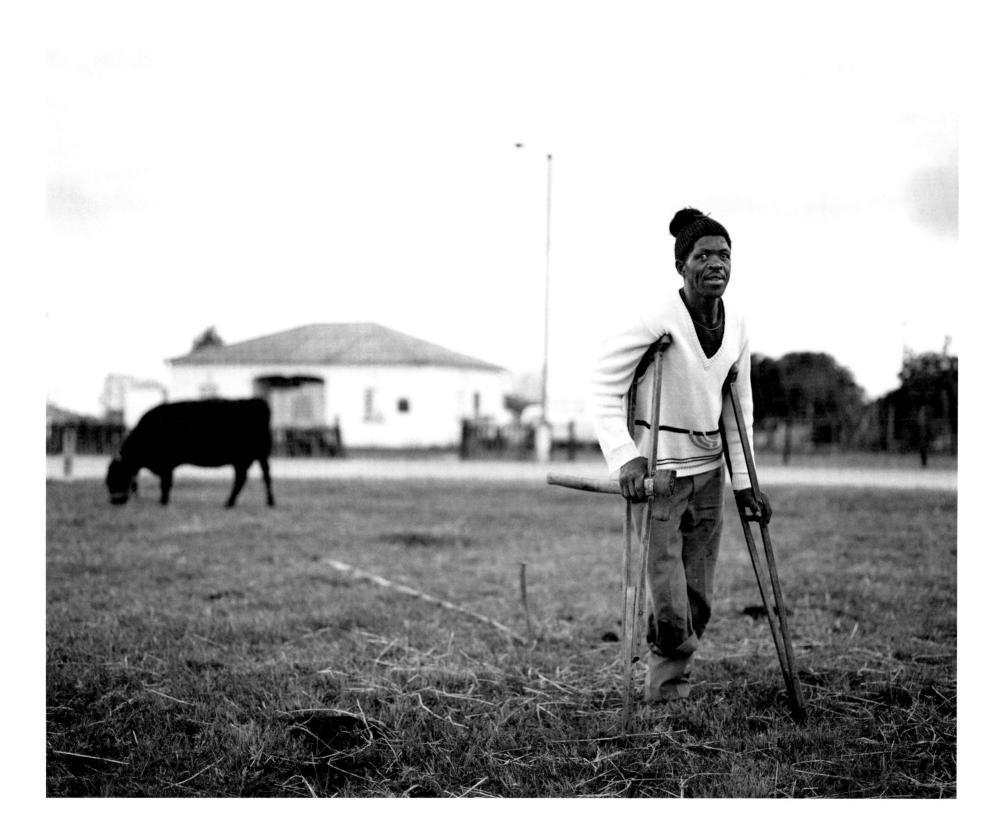

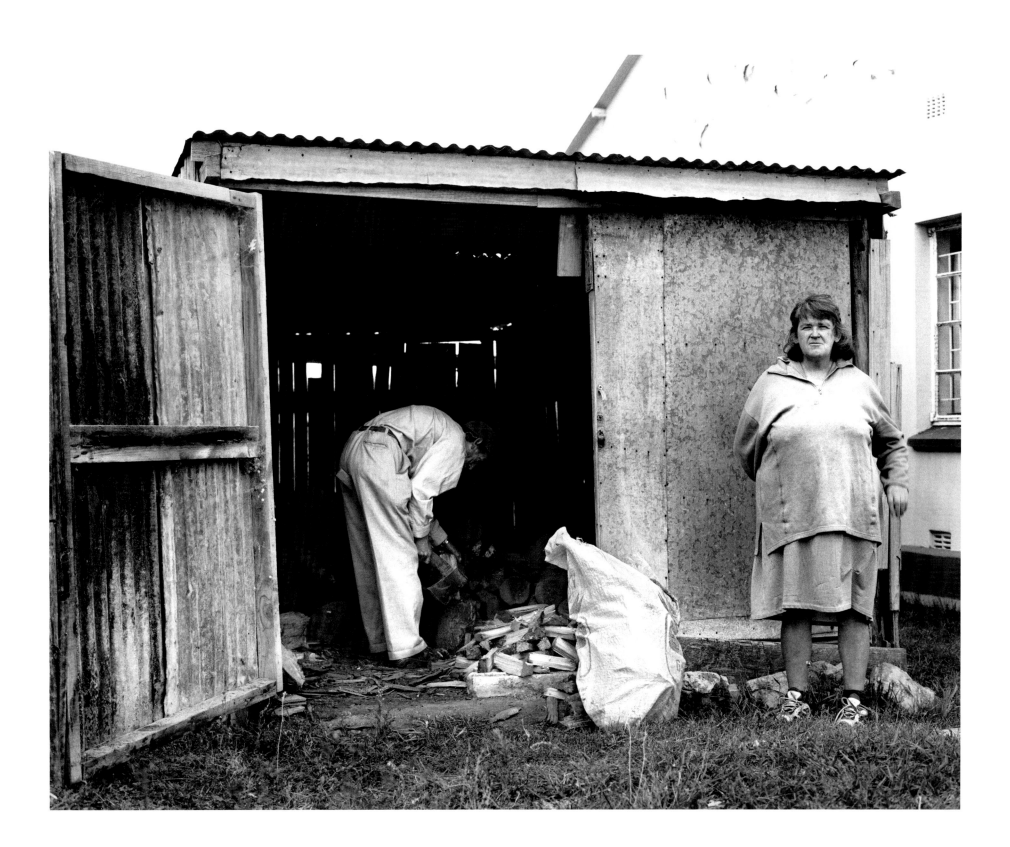

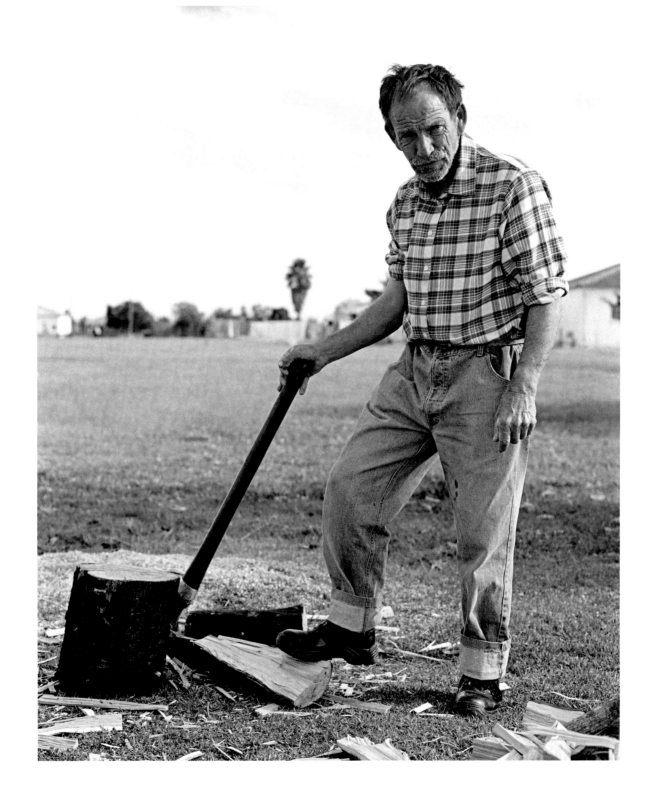

[20] 2 0 0 6

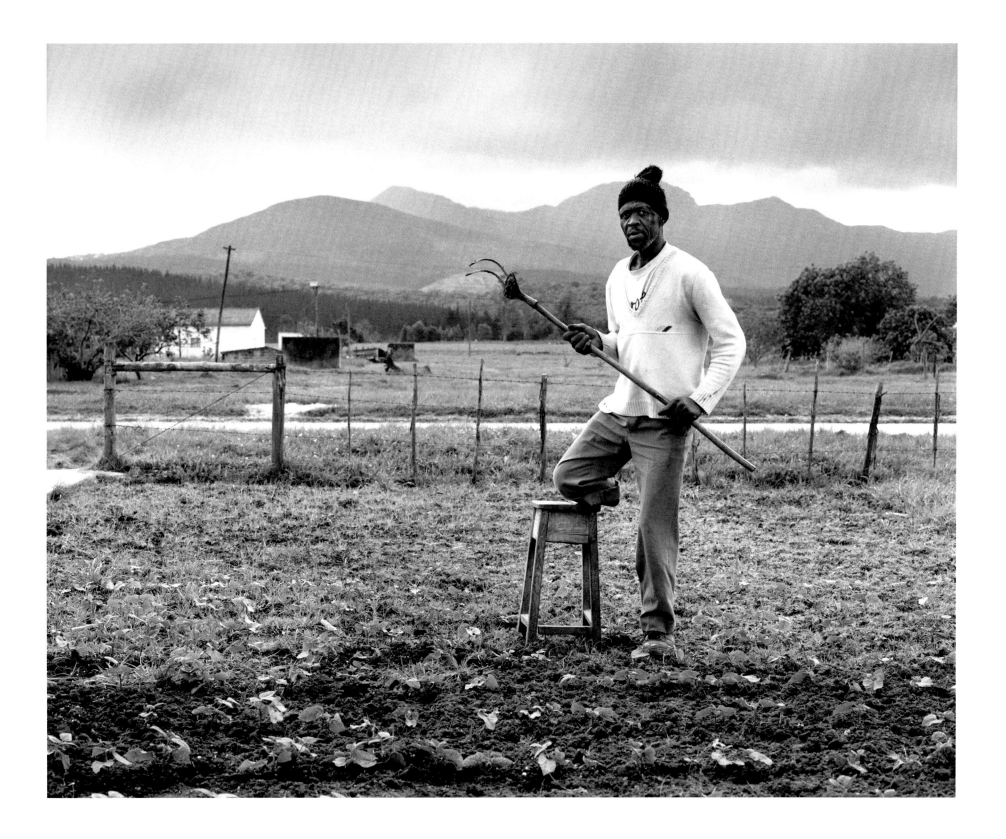

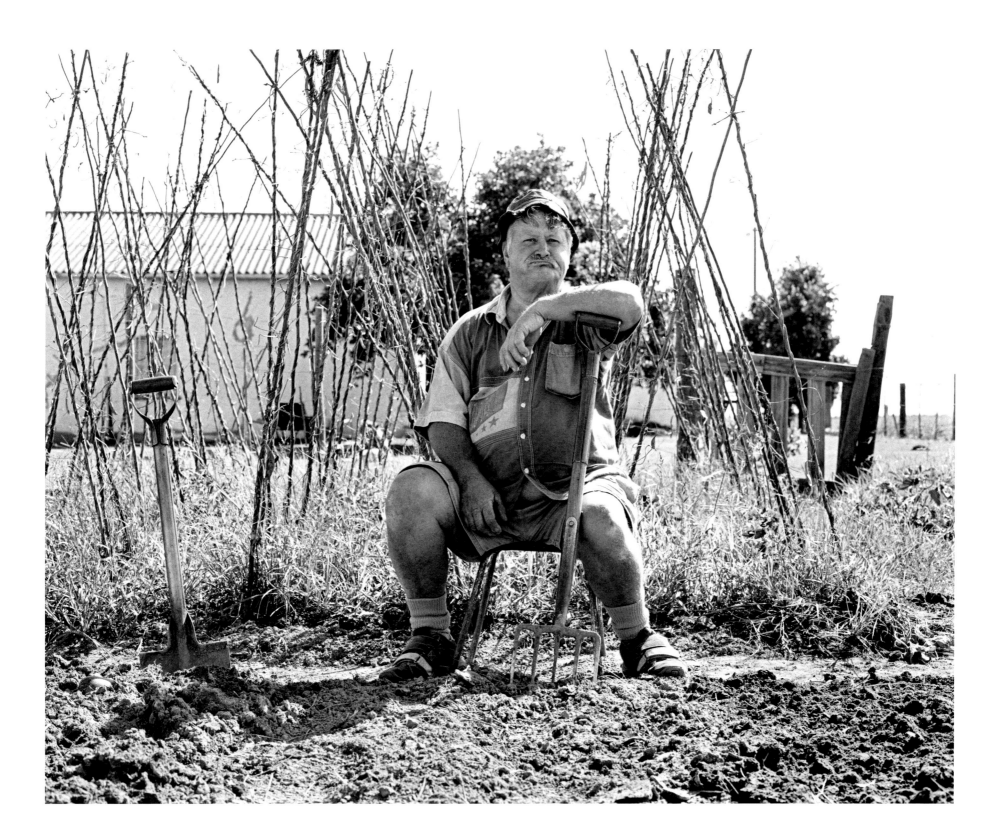

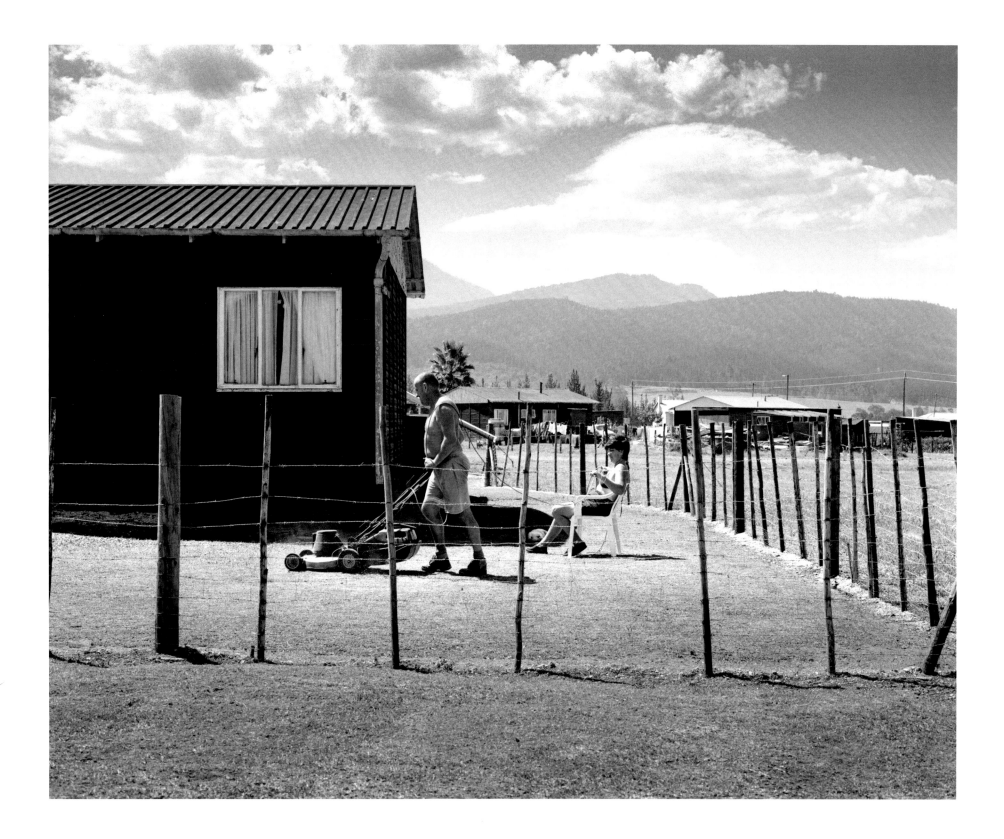

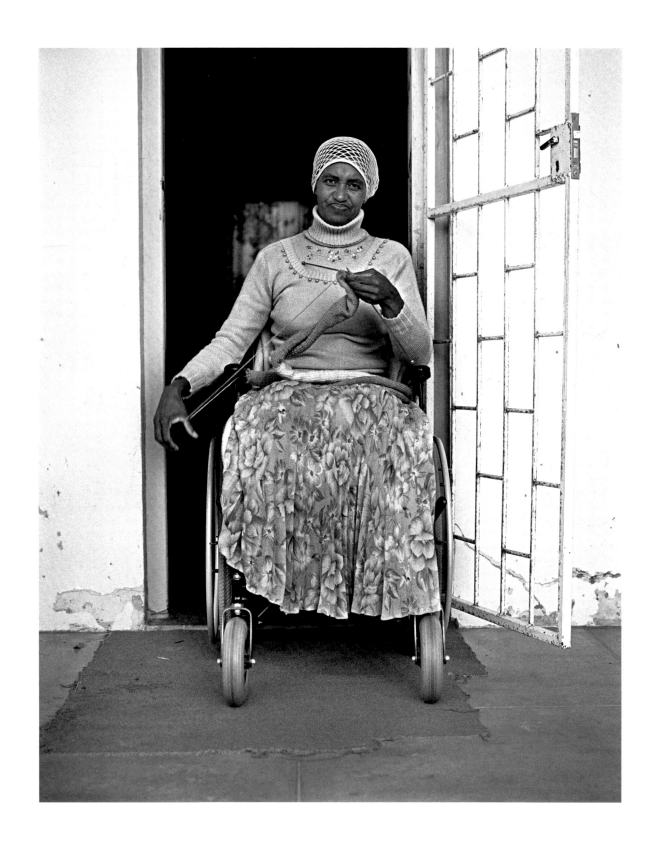

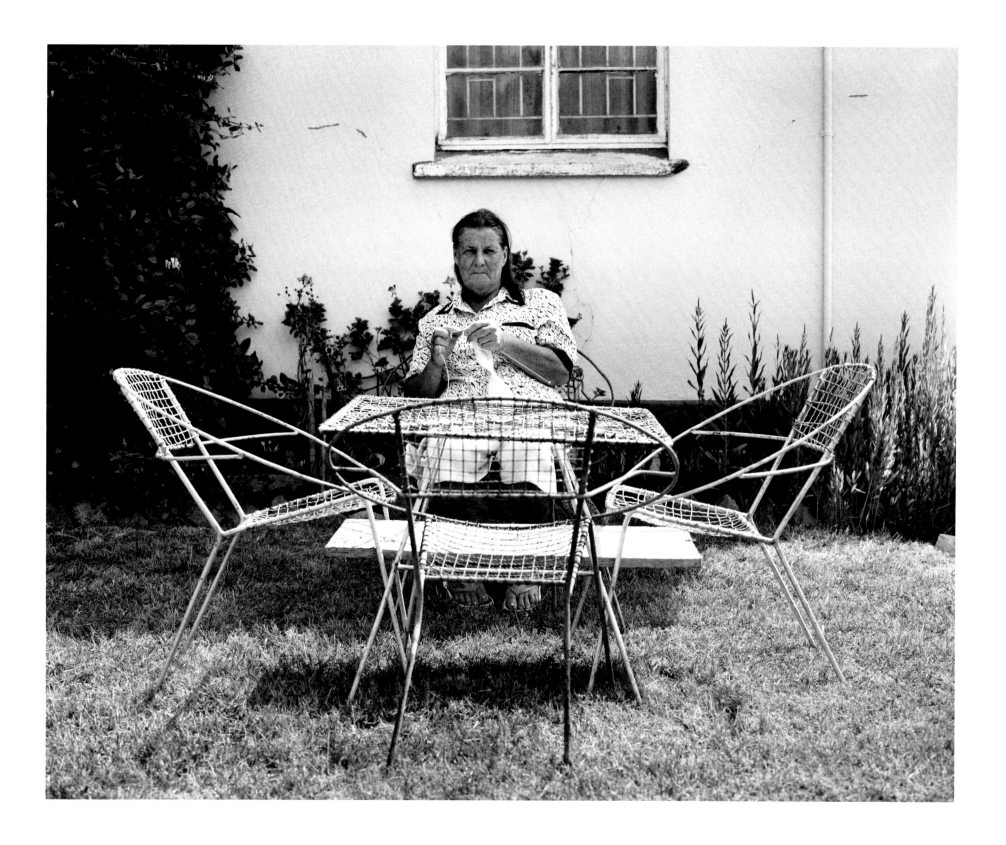

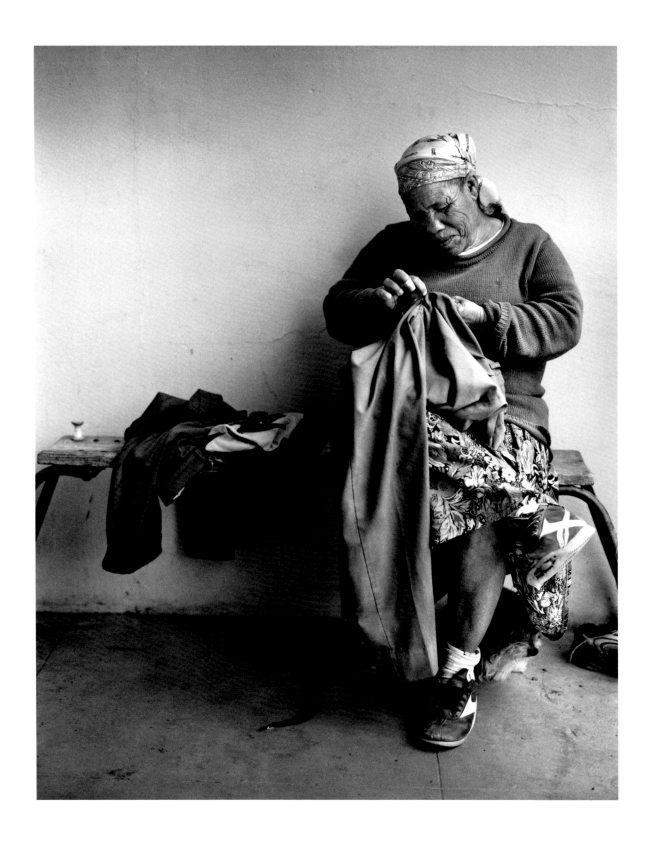

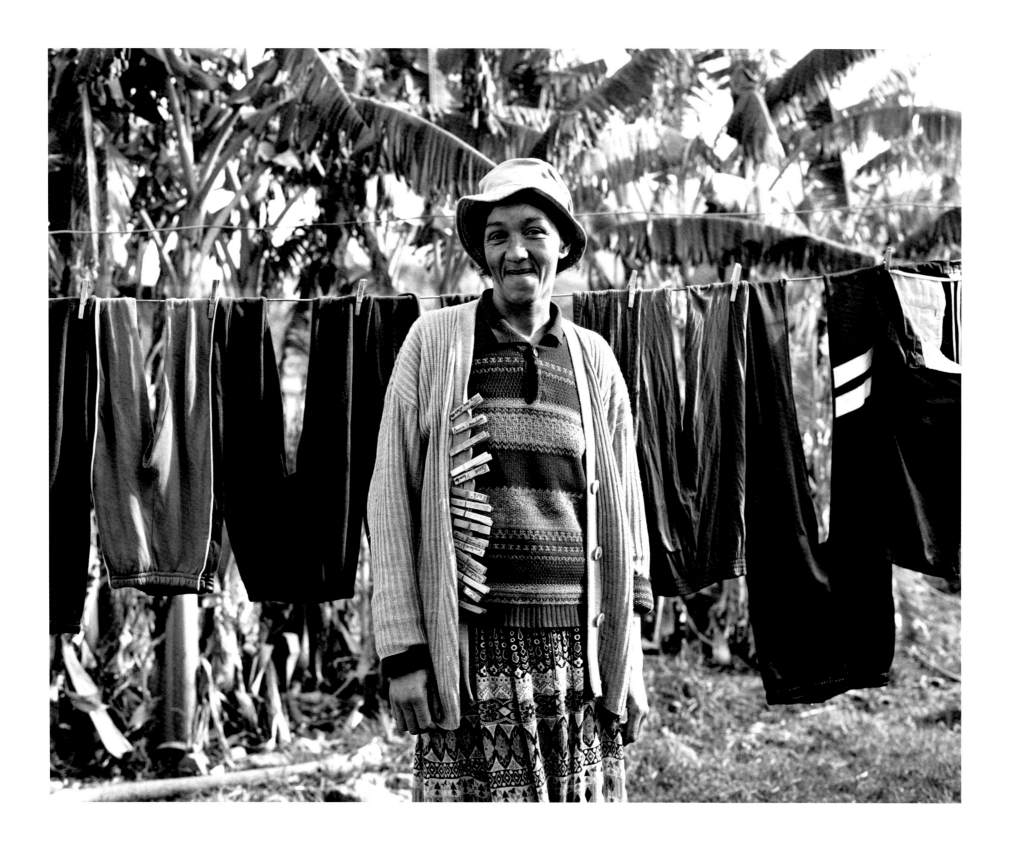

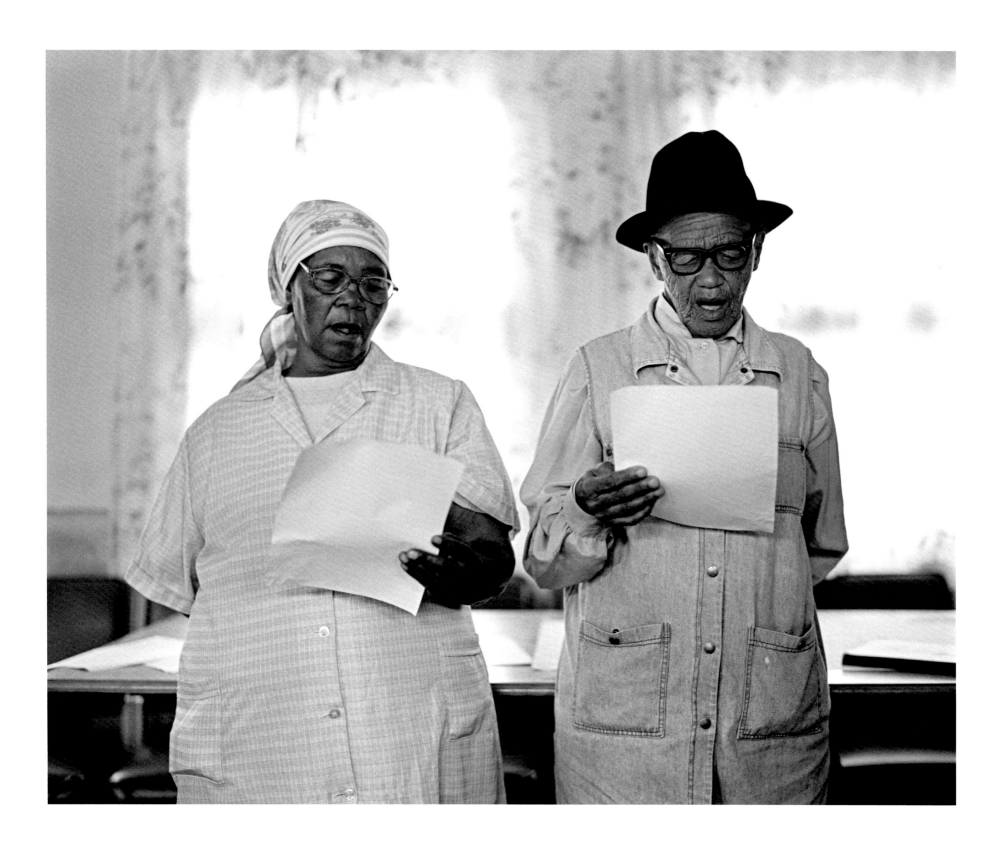

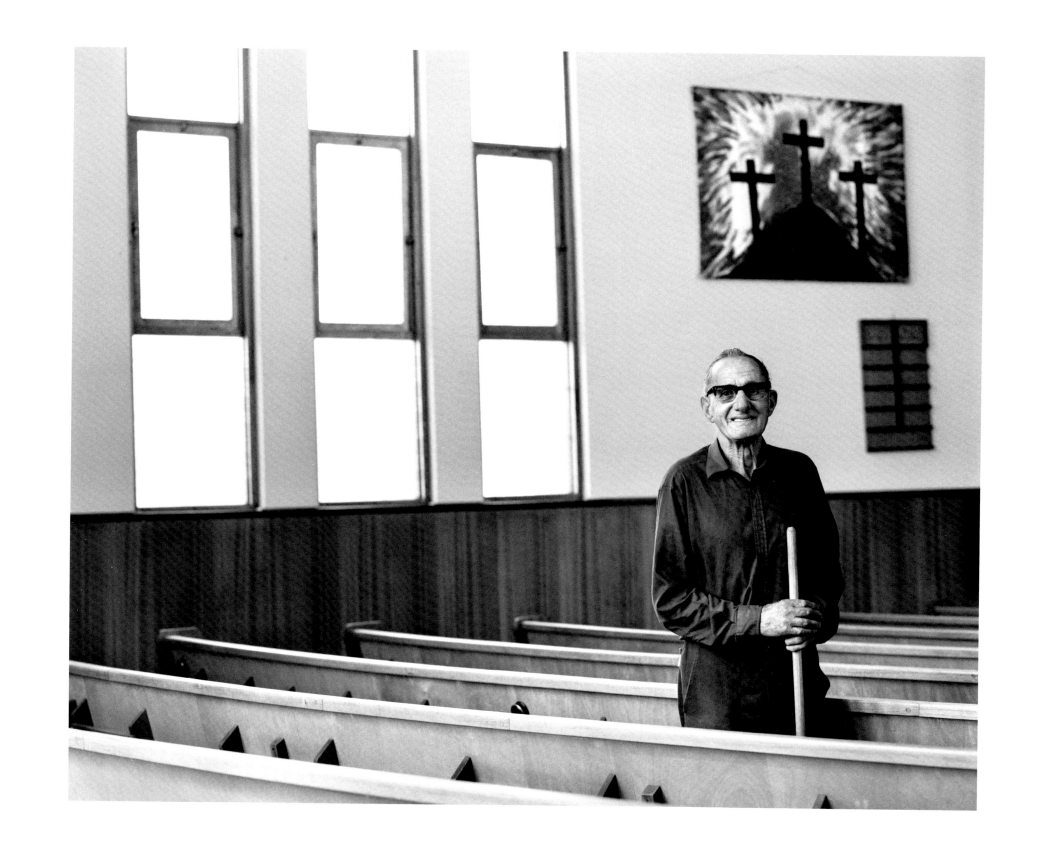

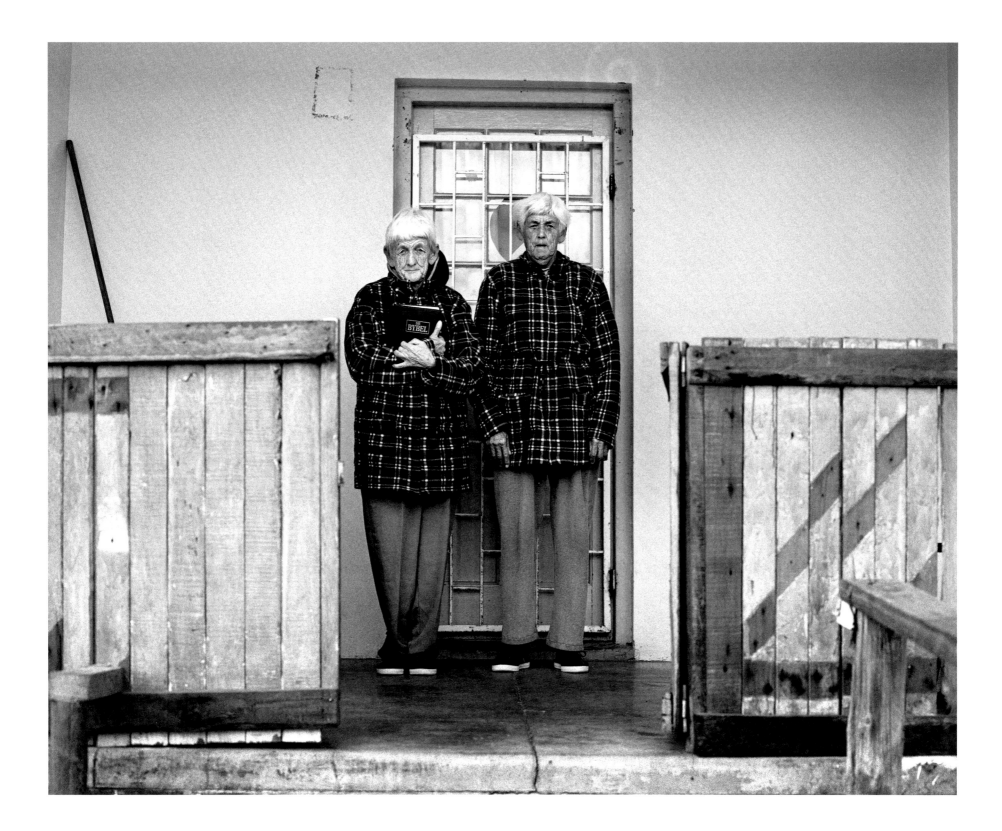

[30] 2 0 0 6

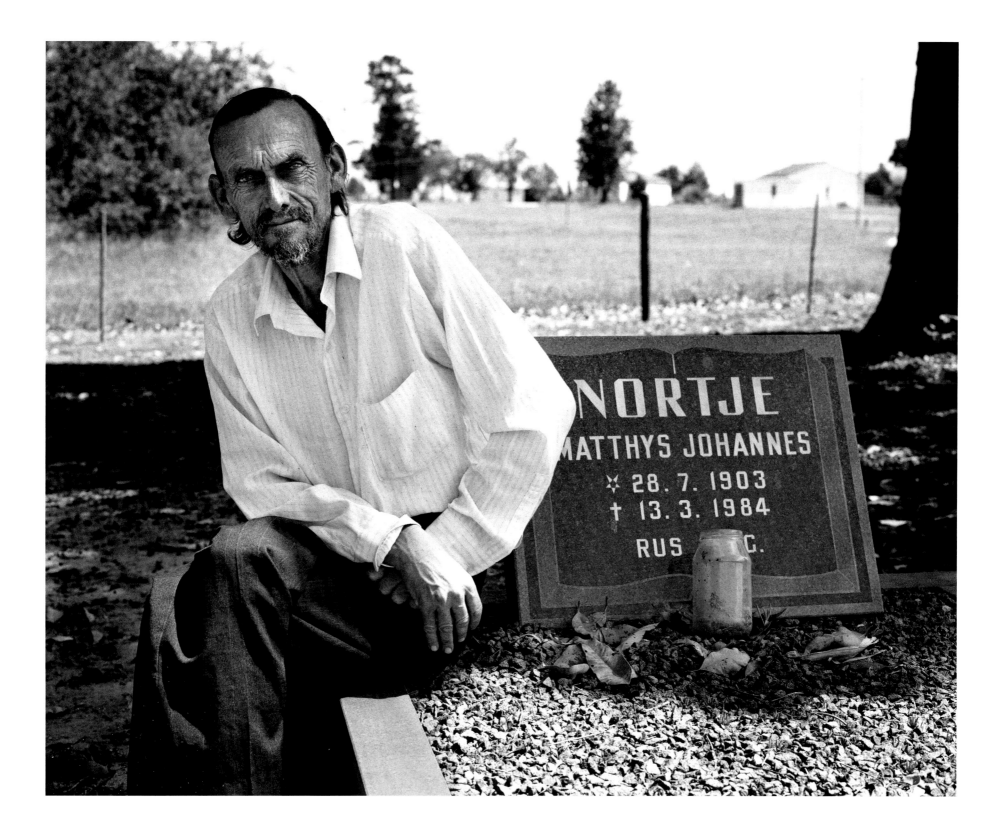

NORTJE
MATTHYS JOHANNES
✶ 28. 7. 1903
✝ 13. 3. 1984
RUS G.

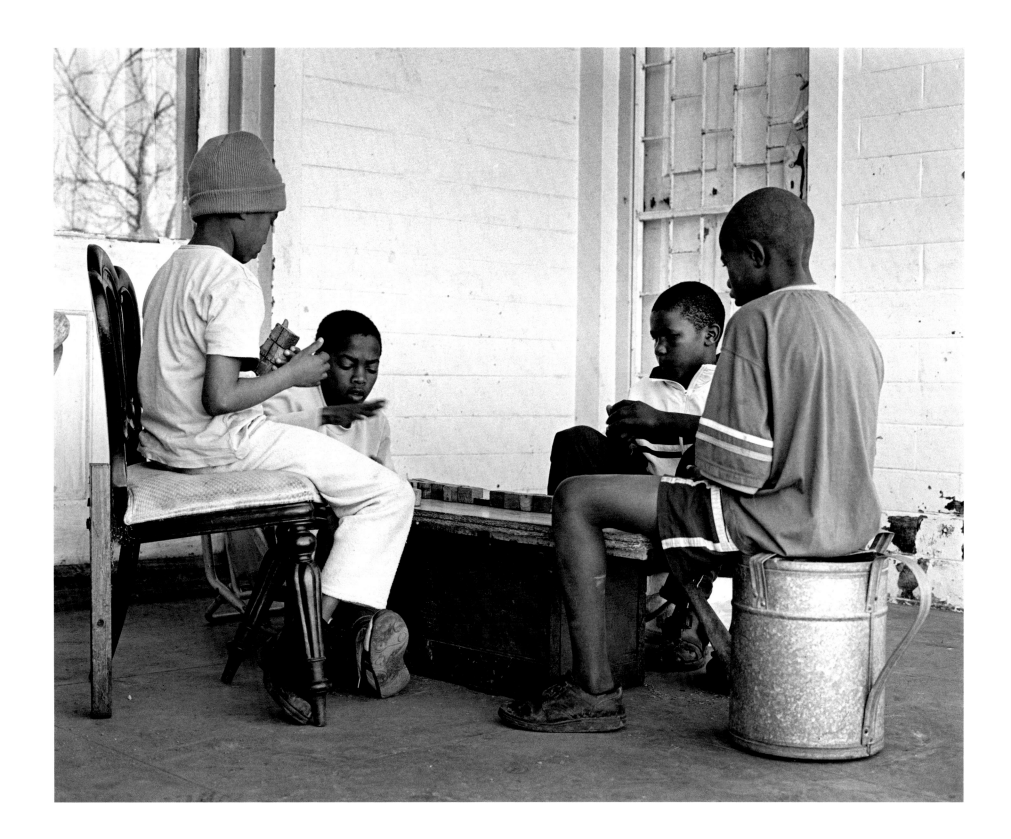

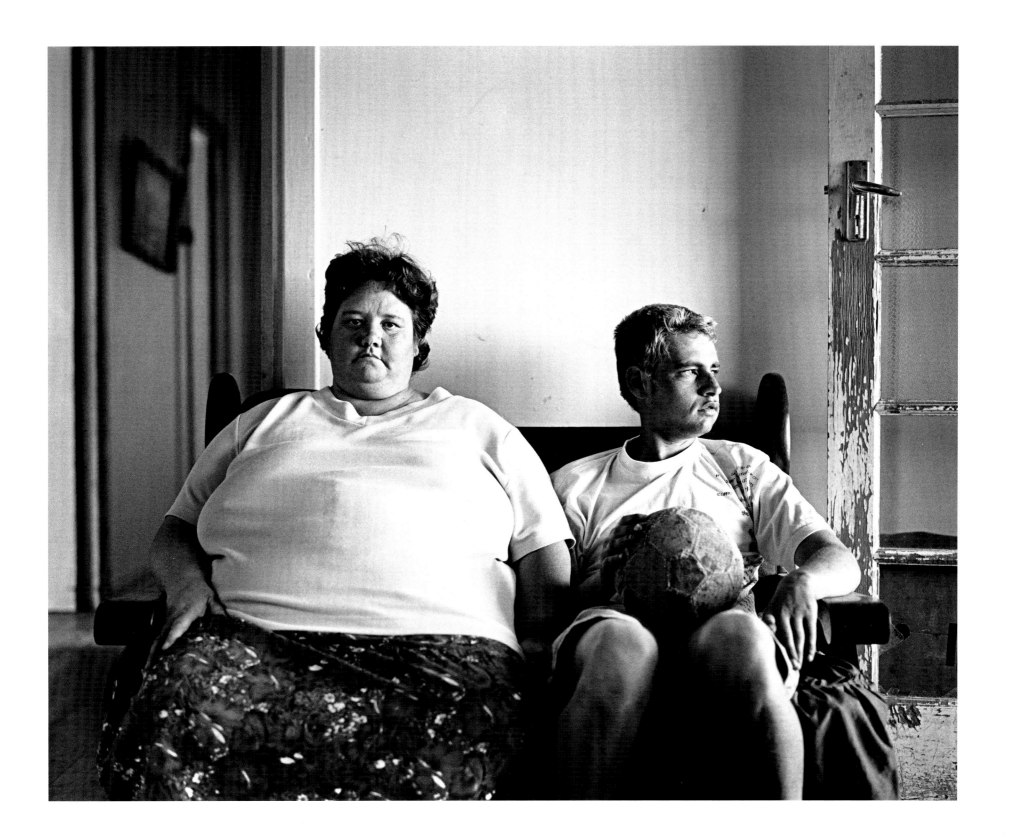

[33] 2 0 0 6

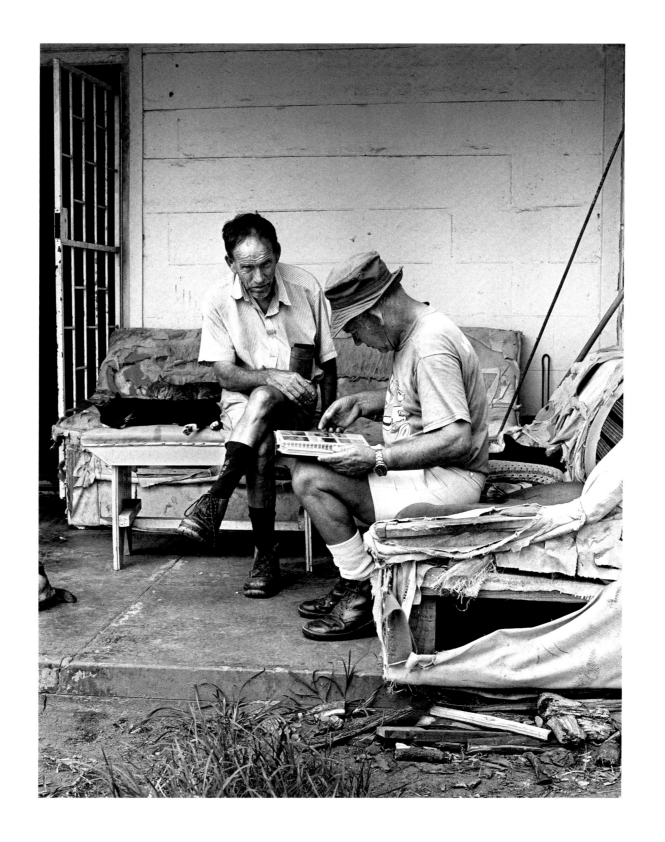

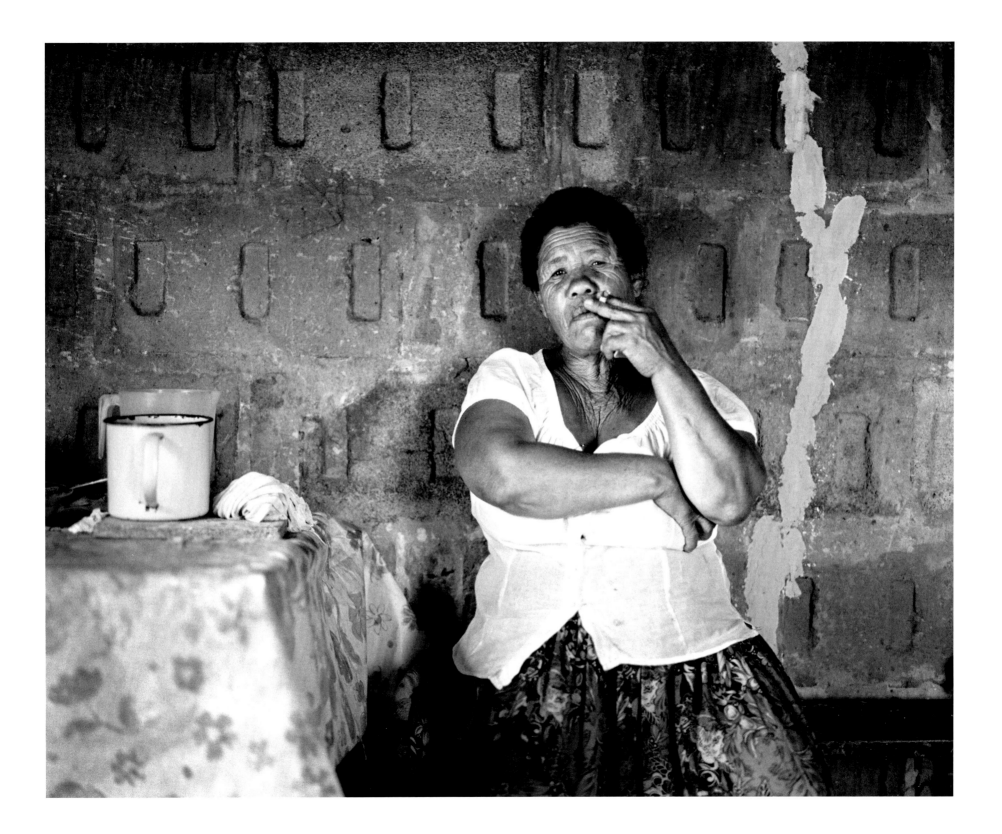

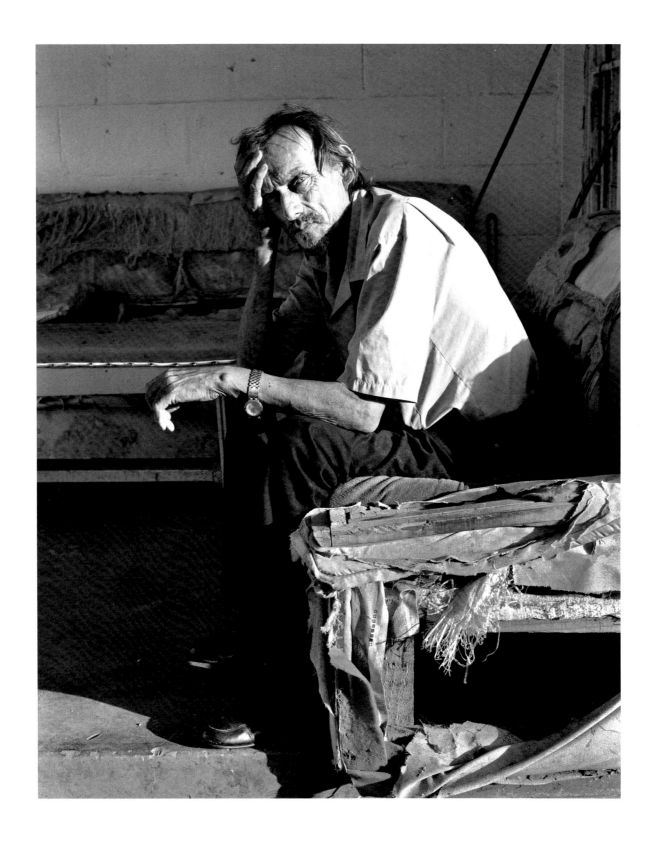

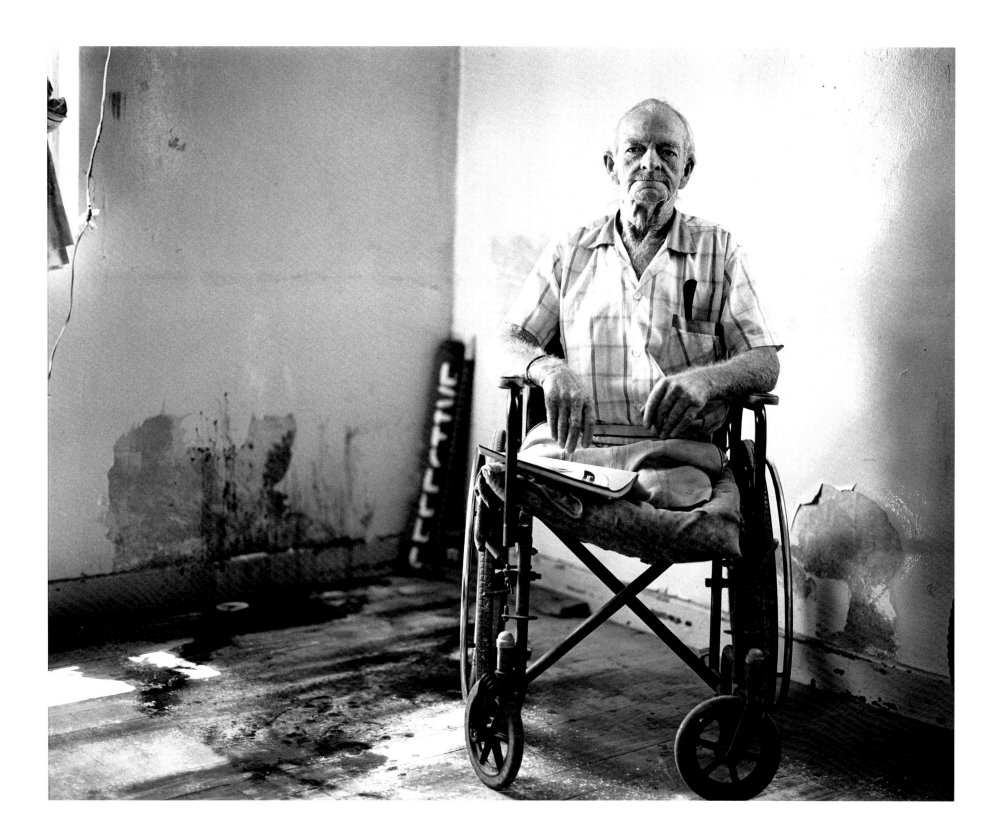

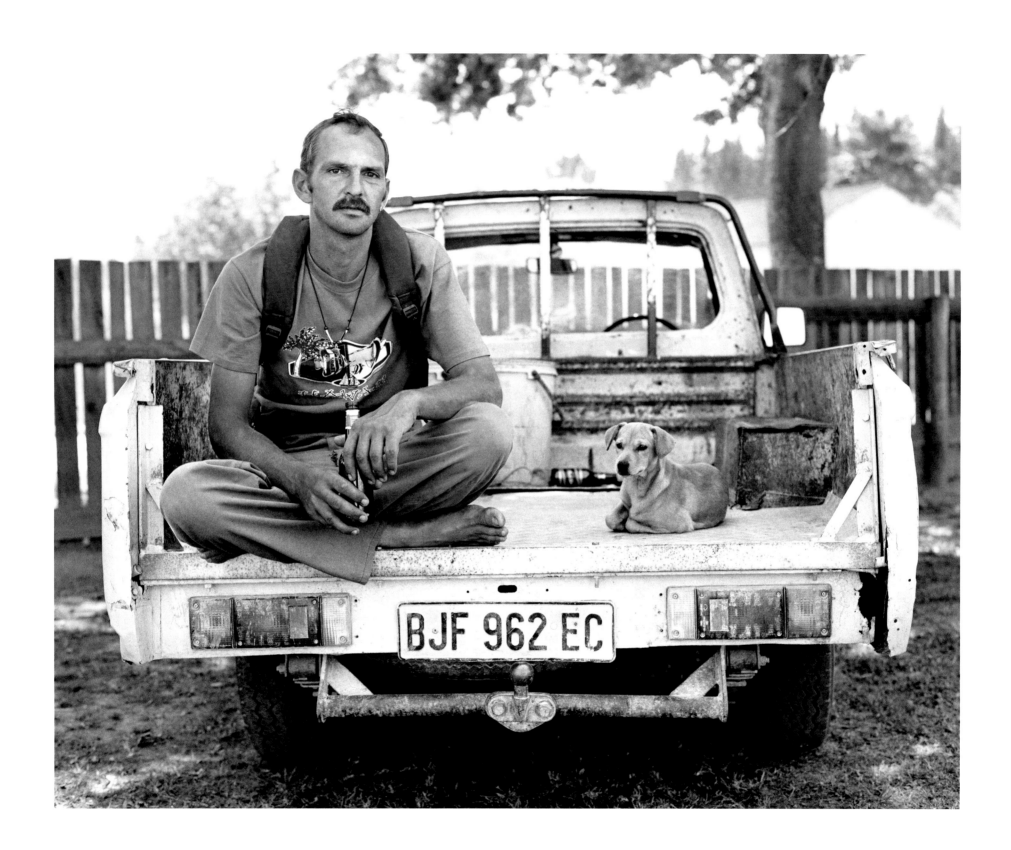

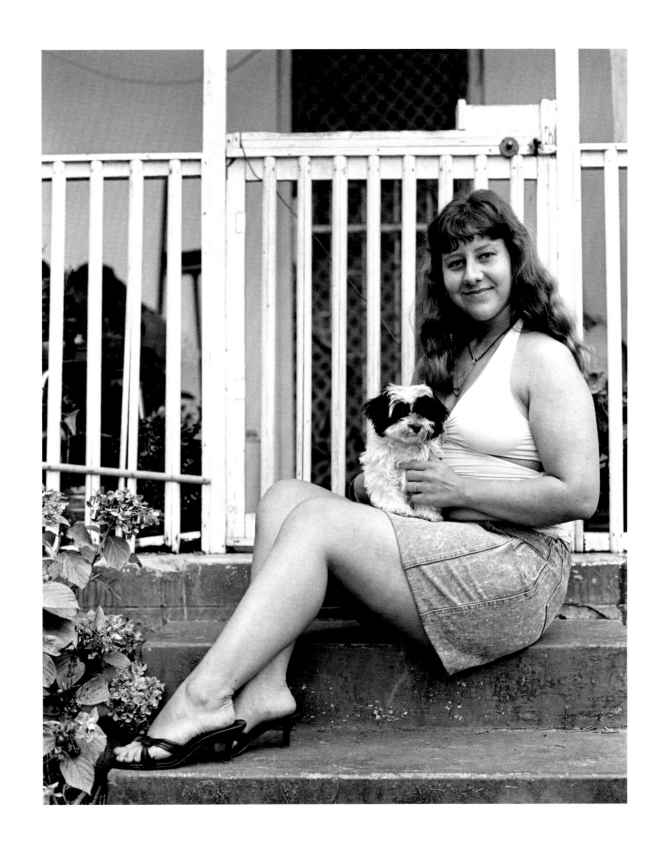

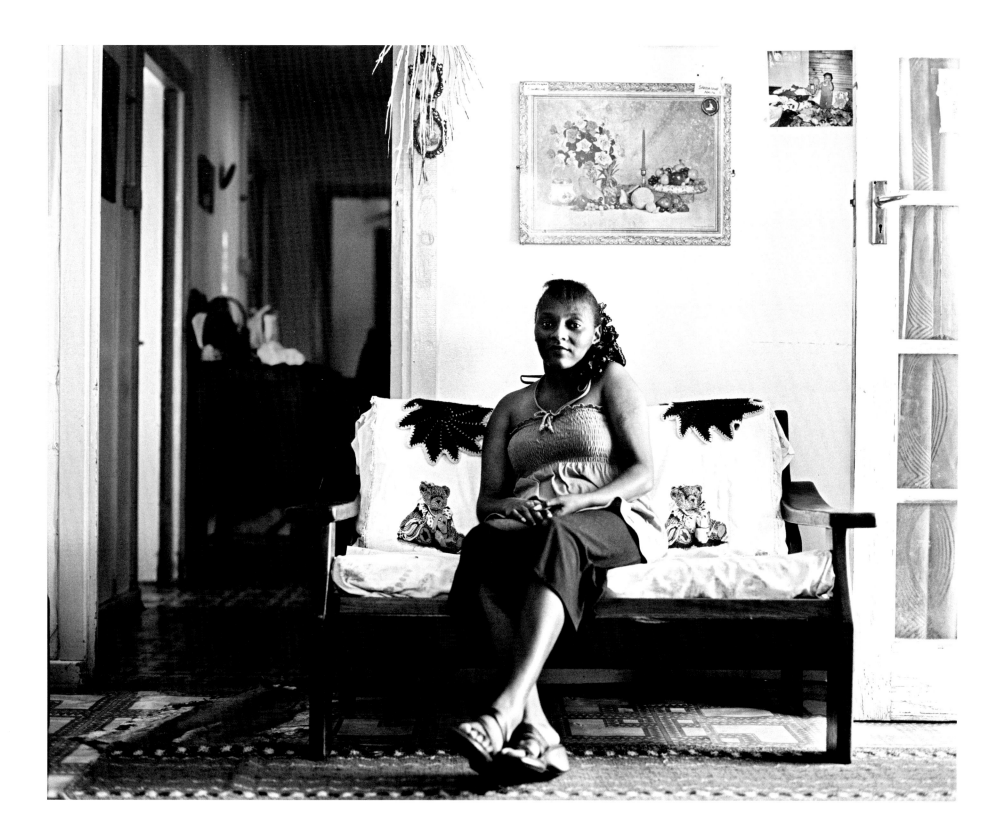

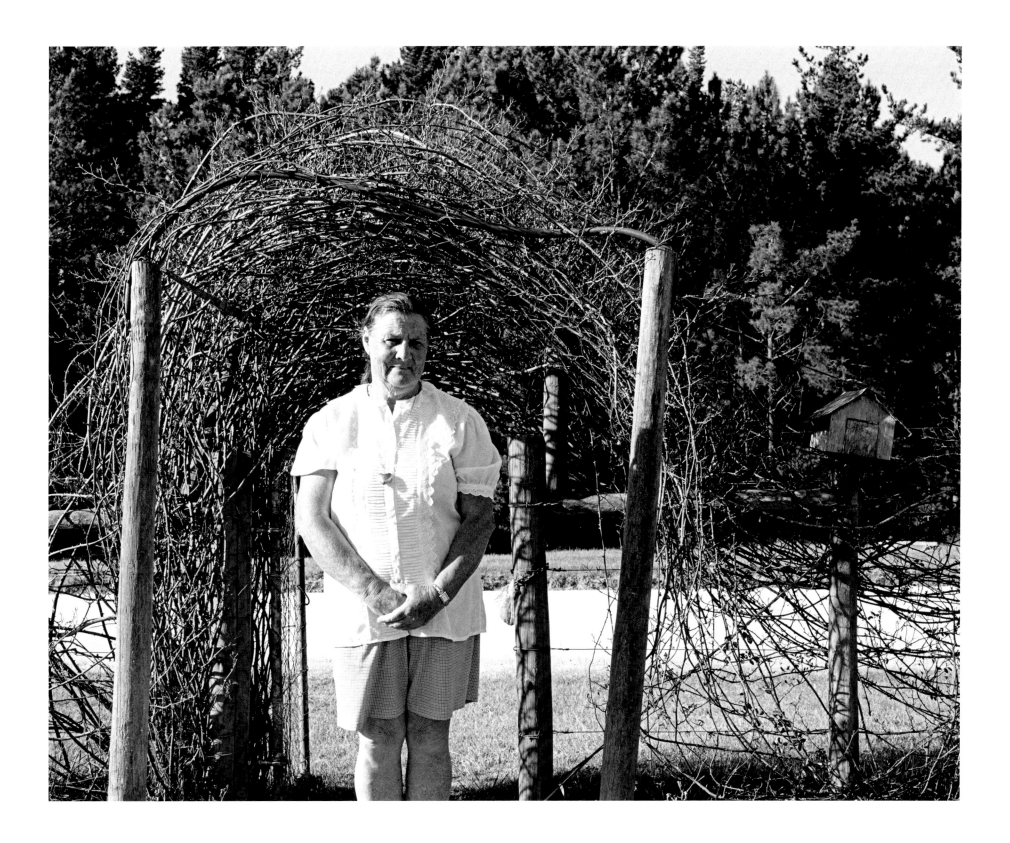

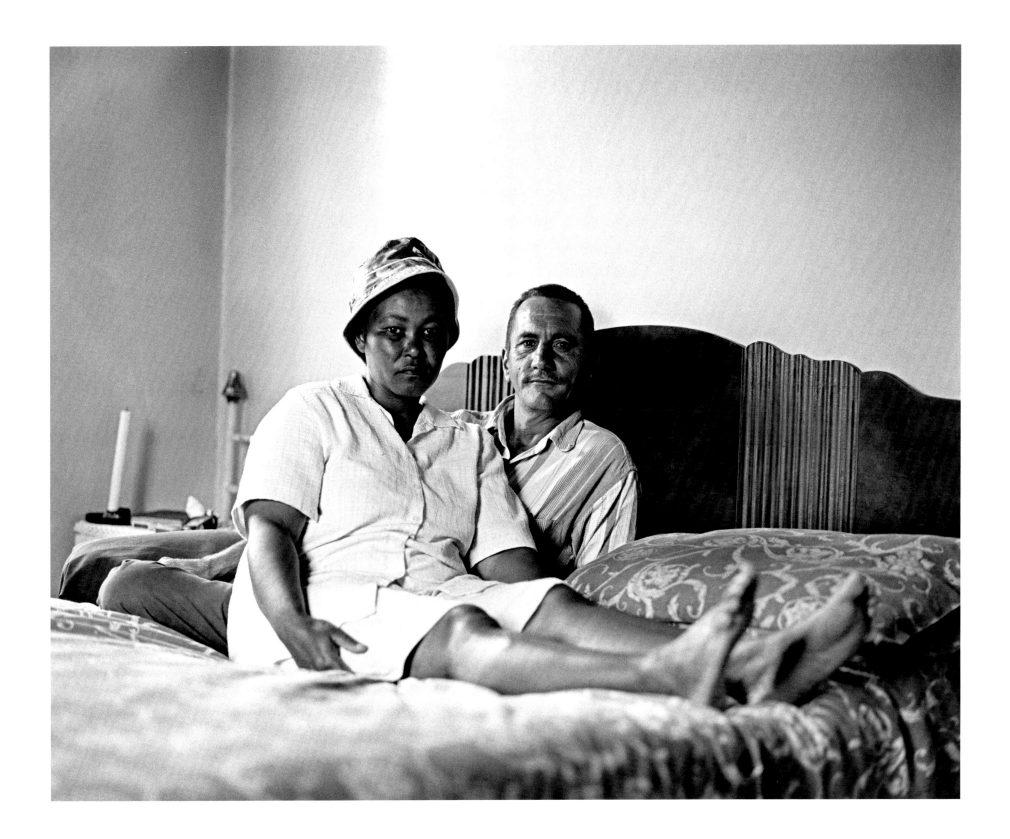

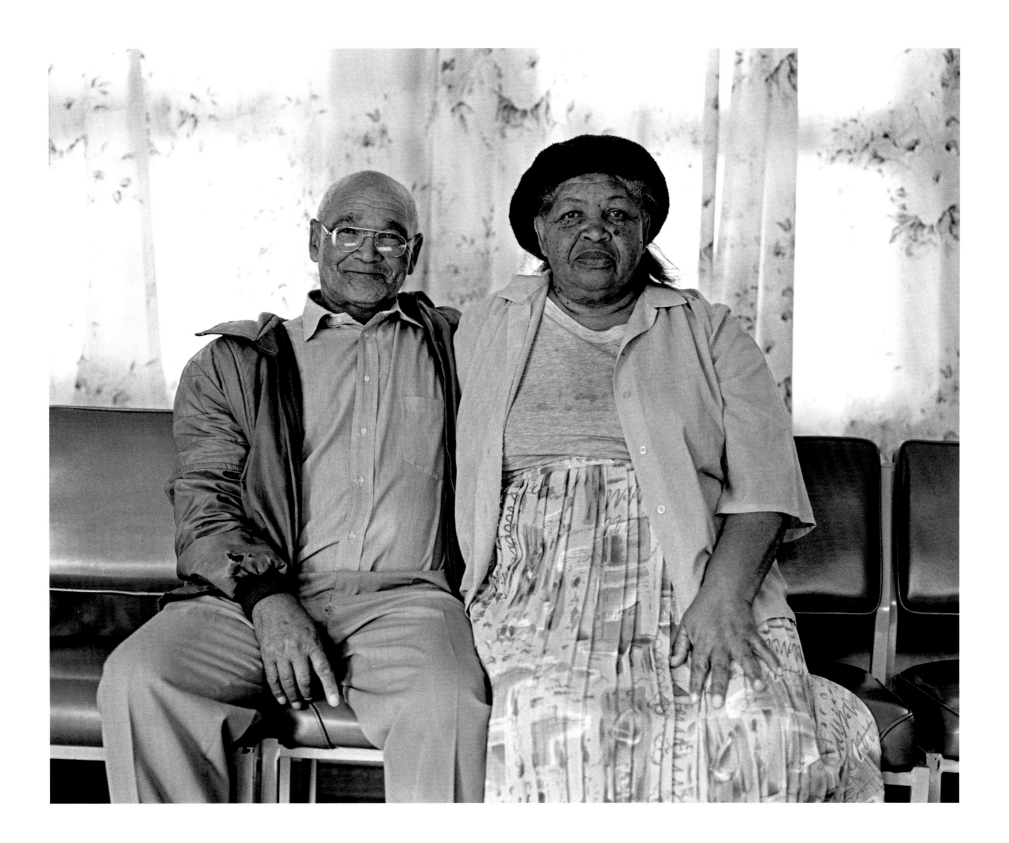

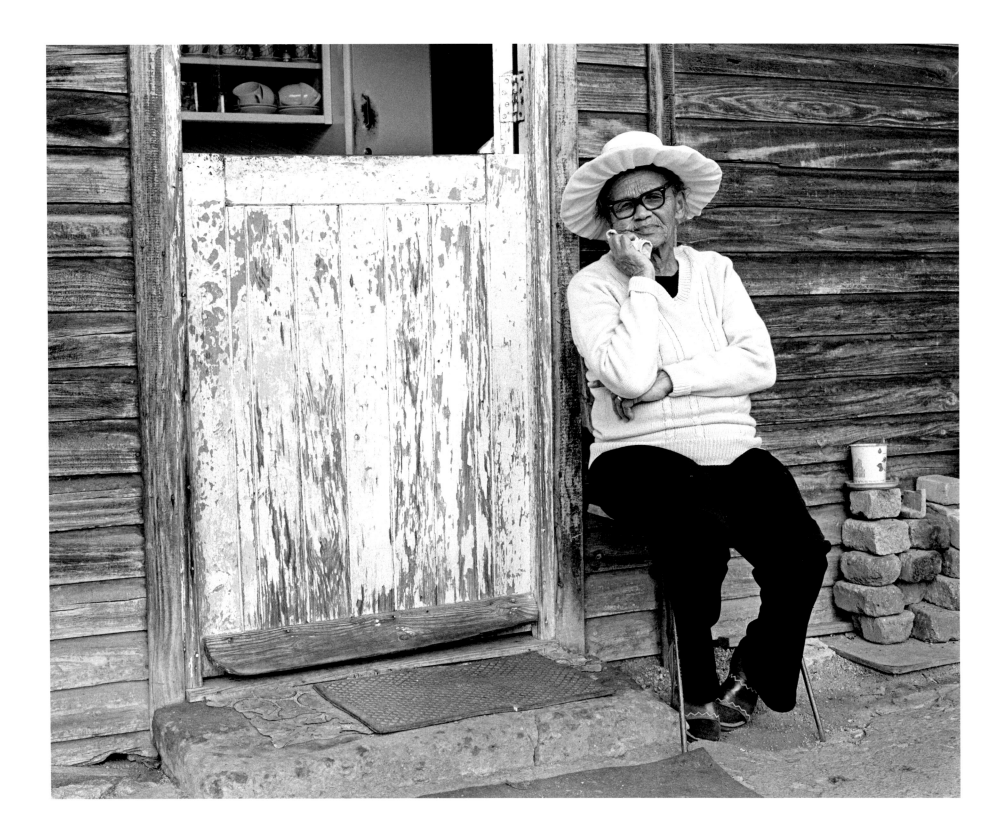

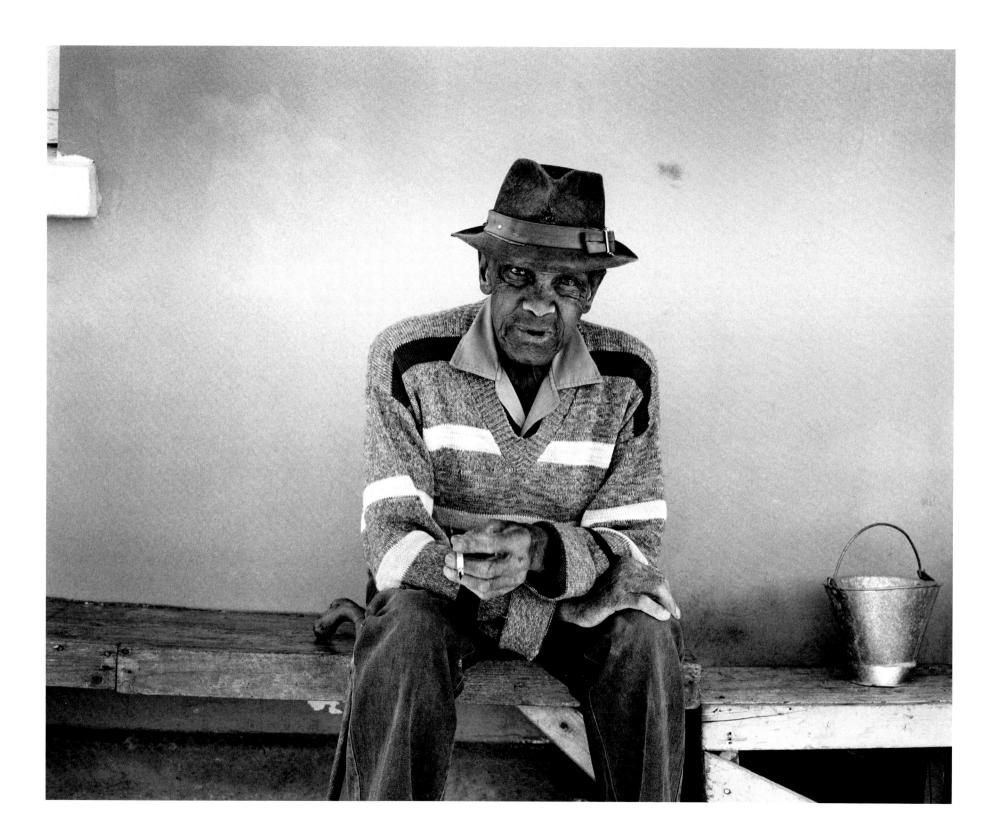

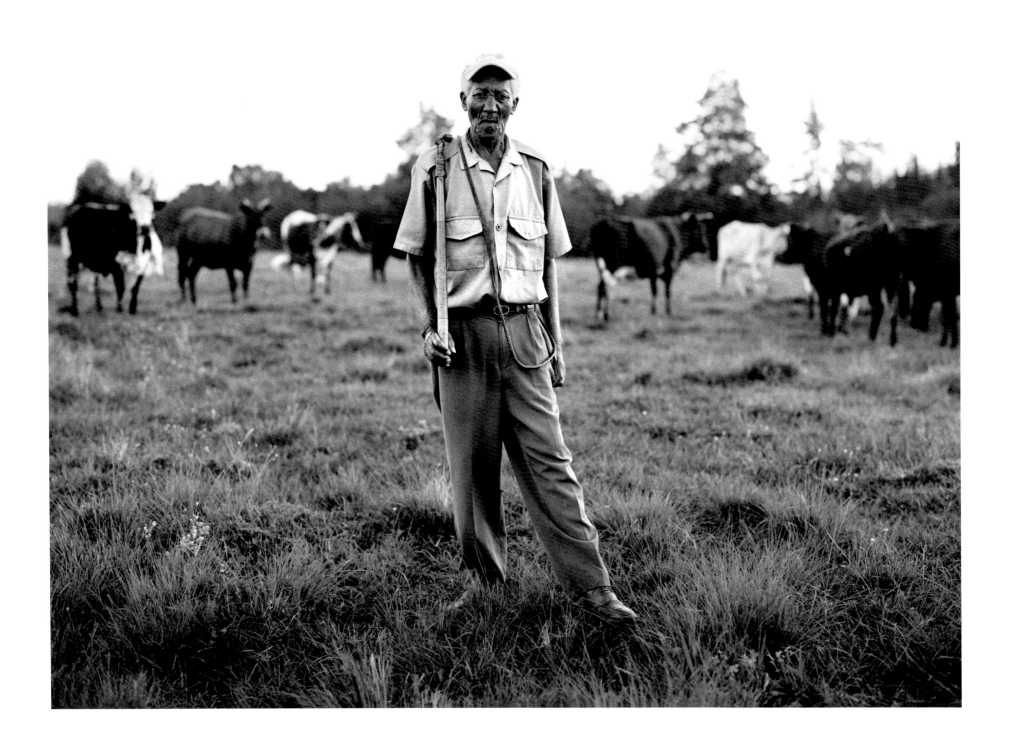

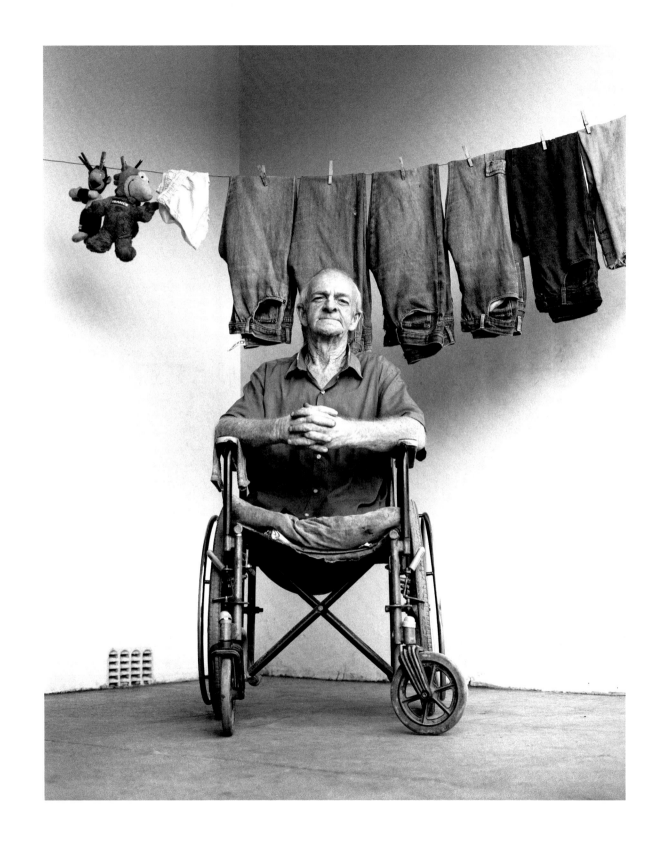

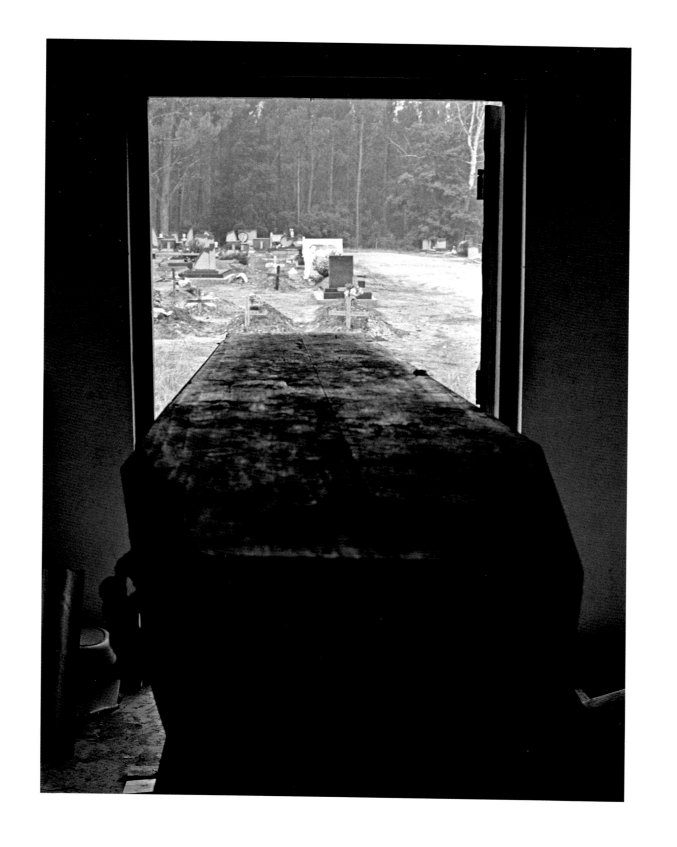

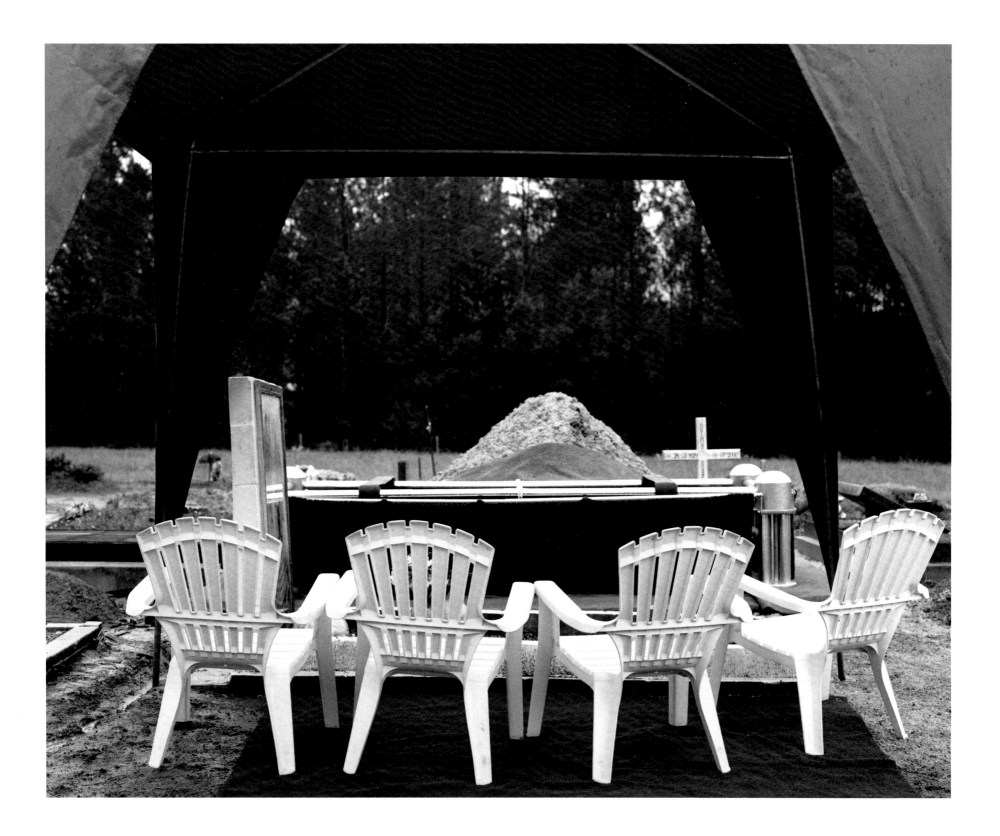

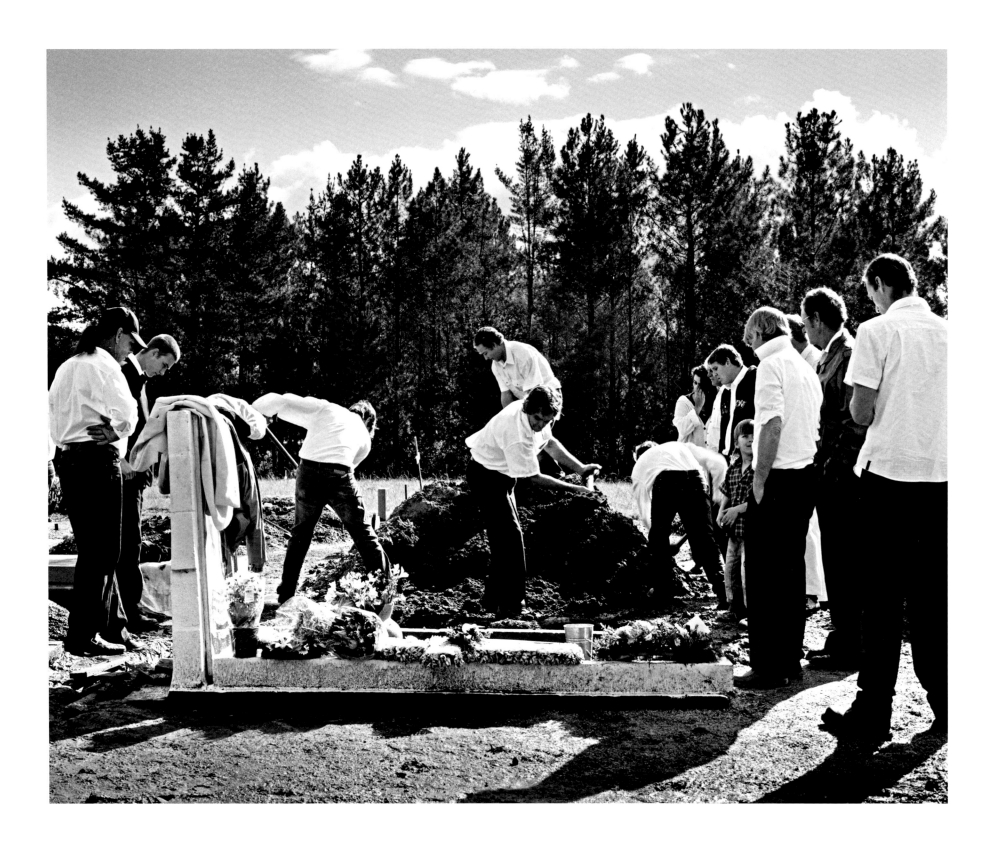

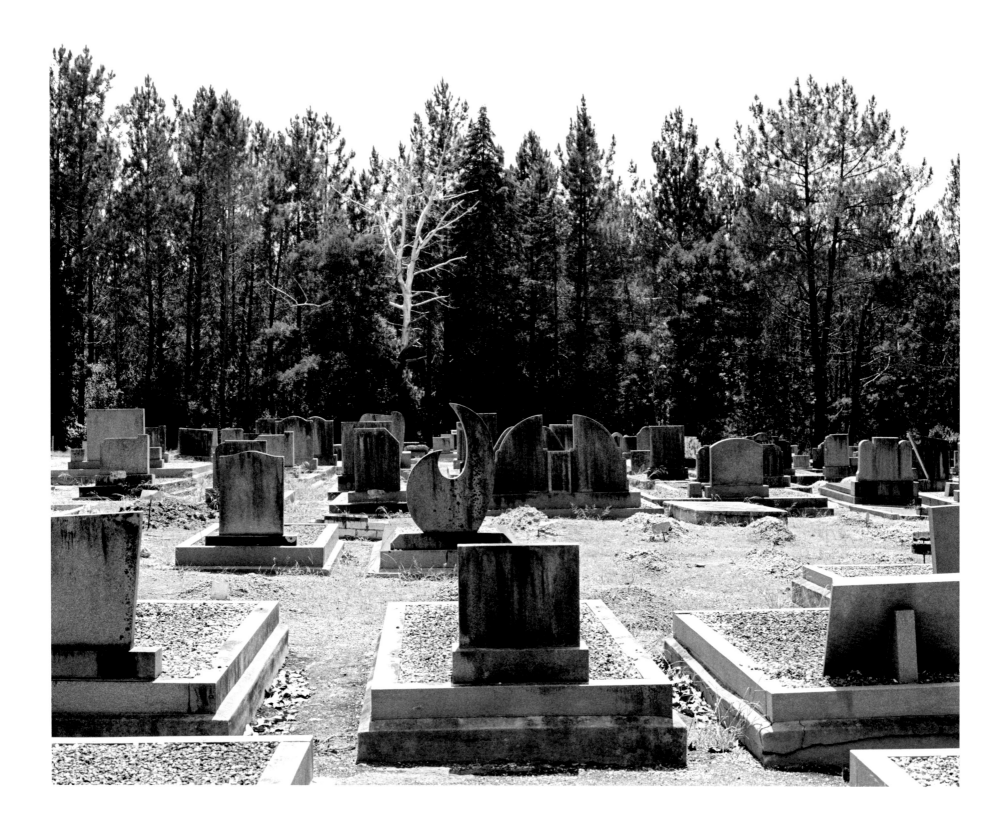

Born in Cape Town 1971, Pierre Crocquet de Rosemond grew up in Klerksdorp, South Africa, a conservative farming and mining town. After school he studied finance at the University of Cape Town and then left to live in London. During the five years he spent abroad, he studied photography at the London College of Printing, after which he returned to South Africa.

His early work focused on aspects of life in South Africa and the African continent. His first book, *Us*, focused on South Africa, while his second book, *On Africa Time*, showcased images from eight African countries—Nigeria, Tanzania, Malawi, Mozambique, South Africa, Namibia, Zambia, and Angola. Since returning to South Africa, he has photographed jazz musicians and the South African music industry. In 2005 Standard Bank commissioned his third book, *Sound Check*, containing Crocquet's images of both local and international artists performing at events in South Africa.

In *Enter Exit* Pierre Crocquet has captured the existential realities of a small community on the periphery, whose daily lives have not escaped the effects of the sociopolitical developments in South Africa. South Africa is a society that has seen dramatic changes in its history, with a particular irony evident in today's post-apartheid society, where division is still inherent, but now falls primarily along economic lines. Social isolation through poverty has become commonplace. It is a situation with which both so-called third and first worlds can increasingly identify. Crocquet forces us to hold up a mirror to ourselves, and the results can be transported to any other postmodern society.

EXHIBITIONS:

2008	*Enter Exit*, Photographers Gallery ZA, solo show, Cape Town
2008	*Enter Exit*, Moba Art Gallery, solo show, Brussels
2008	*Enter Exit*, Gallery Caprice Horn, solo show, Berlin
2007	Photo Miami, Gallery Caprice Horn
2007	Nouvelles Rencontres Africaines de la Photographie de Bamako, Mali
2007	Cornice Art Fair, Gallery Caprice Horn
2007	*Reality Bites*, Gallery Caprice Horn, group show, Berlin, with Andres Serrano, Roger Ballen, Joel-Peter Witkin, Erwin Olaf, et al.
2007	Photographers Gallery ZA, group show, Cape Town
2007	Art Cologne, Gallery Caprice Horn
2006	Standard Bank Gallery, Johannesburg

AWARDS:

2007	*Photo District News*, 30 Emerging Photographers to Watch
2003	Brett Kebble Arts Awards, finalist for Photography Award
2002	Mondi Photographer of the Year award

PUBLIC COLLECTIONS:
Bibliothèque nationale de France, Paris

CORPORATE COLLECTIONS:
Credit Suisse
Standard Bank

BOOKS PUBLISHED:
Sound Check, Bell Roberts Publishers, 2005
On Africa Time, Bell Roberts Publishers, 2003
Us, Bell Roberts Publishers, 2002

LIST OF WORKS

[EXIT]

For Jeannine and Gavin and the people whose photographs are included in this book.

Enter Exit is a collaboration and I would like to thank the following people:
My sister Jeannine and Gavin du Venage for their suggestions and encouragement. Dennis da Silva for his friendship, editing, and skillful printing. Your advice on imagery and assistance have been invaluable. My mother, Jeanne, for her selfless support. Damon and Alex Forbes for their friendship and generosity over the years. Andreas Kahlau and all the staff at Silvertone for their efficient, easygoing attitude that makes working with them a pleasure. Caprice Horn for her energy and drive and for making work a lot of fun. Roger Ballen for his time taken to pass on his knowledge. François Smit for his great design and dry, quirky wit. Rick Wester for his astute and sensitive observations. Eugen Blume for his formulation and incisive comments. Donna Stonecipher and Clemens von Lucius for their copyediting. Allison Plath-Moseley and Marie-Liesse Zambeaux for the translations. Annette Kulenkampff, Cristina Steingräber, Tas Skorupa, Jennifer Seefeld, Christine Emter, and the team at Hatje Cantz for believing in the work and ensuring the process ran effortlessly.

This catalogue is published in conjunction with the exhibition
Nouvelles Rencontres Africaines de la Photographie de Bamako, Mali
November 23–December 23, 2007

Editor: Caprice Horn
Copyediting: Clemens von Lucius, Donna Stonecipher, Marie-Liesse Zambeaux
Translations: Wolfgang Himmelberg, Allison Plath-Moseley, Marie-Liesse Zambeaux

Graphic design: François Smit, QUBA Design & Motion
Typeface: Berkeley
Production: Christine Emter
Paper: Galaxi Supermat, 170 g/m²
Binding: Kunst- und Verlagsbuchbinderei, Leipzig

Scanning and grading: Silvertone International (Pty) LTD

Printing: Dr. Cantz'sche Druckerei, Ostfildern
© 2008 Hatje Cantz Verlag, Ostfildern; and authors
© 2008 for the reproduced works by Pierre Crocquet: the artist

Published by:
Hatje Cantz Verlag
Zeppelinstrasse 32
73760 Ostfildern
Deutschland / Germany
Tel. +49 711 4405-200
Fax +49 711 4405-220
www.hatjecantz.com

Hatje Cantz books are available internationally at selected bookstores and from the following distribution partners:

USA/North America – D.A.P., Distributed Art Publishers, New York, www.artbook.com
UK – Art Books International, London, www.art-bks.com
Australia – Tower Books, Frenchs Forest (Sydney), www.towerbooks.com
France – Interart, Paris, www.interart.fr
Belgium – Exhibitions International, Leuven, www.exhibitionsinternational.be
Switzerland – Scheidegger, Affoltern am Albis, www.ava.ch
For Asia, Japan, South America, and Africa, as well as for general questions, please contact Hatje Cantz directly at sales@hatjecantz.de, or visit our homepage at www.hatjecantz.com for further information.

ISBN 978-3-7757-2084-7

Printed in Germany

Cover illustrations:
Front cover: 5, 2006
Back cover: 47, 2006